IMAGES
of America

SPOTSWOOD

The authors would like to dedicate this book to the late Lou Sarti.
We will miss his positive attitude and cheery smile.

IMAGES
of America

SPOTSWOOD

Bruce Eckman, Jack Eichenlaub, and Roy Dey Jr.

ARCADIA

First printed in 2003.

Published by Arcadia Publishing,
an imprint of Tempus Publishing Inc.
2A Cumberland Street
Charleston, SC 29401

Printed in Great Britain.

Library of Congress Catalog Card Number: 2003103942

For all general information, contact Arcadia Publishing:
Telephone 843-853-2070
Fax 843-853-0044
E-mail sales@arcadiapublishing.com

For customer service and orders:
Toll-free 1-888-313-2665

Visit us on the Internet at www.arcadiapublishing.com.

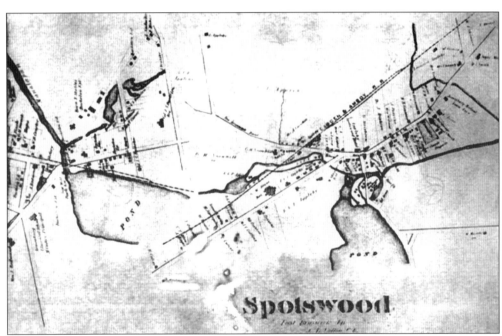

In the early 1800s, as the industrial age began, Spotswood's manufacturers turned to new products; snuff and paper were the most important. Isaac DeVoe was a local resident who started a snuff mill on the tract of land that had once held a foundry, sawmill, and flour mill. The land called "the island" is on the road that now bears his family name.

CONTENTS

ACKNOWLEDGMENTS

To document the entire history of a municipality, even a small borough like Spotswood, requires the cooperation and input of many individuals. First and foremost, the authors would like to thank Janine V. Balazs, director of the Spotswood Office on Aging, for her efforts in spreading the word about this project to the senior citizens of the borough. It was with their help that we collected most of the photographs that wound up in this publication. Kim A. Luczkow spent many hours collecting, scanning, and organizing the more than 200 photographs that made the cut and were chosen to convey the early part of the 95-year history of the borough.

This book was a project endorsed by the Spotswood Economic Development Commission, under the auspices of chairmen Lou Sarti and John Chludzniski. This publication has been fully endorsed by Mayor Barry Zagnit and the Spotswood Borough Council, Howard Keenan, James Shearn, Kevin Meade, Curt Stollen, and Judy Ruffo. Among his contributions, the mayor provided many photographs and captions, particularly concerning the Spotswood First Aid Squad.

Another special acknowledgment goes to two of our grammar-school teachers, Donald MacGuigan and Lillian Mortimer. With a number of others, they produced an audio-visual presentation memorializing the first 75 years of Spotswood history. Both have been longtime residents of the Spotswood area and offered many first-person accounts of people, places, and things in town.

We also express our appreciation to Tressa (Uhl) Baumann, Gloria (Sengstack) Uhl, and Harvey Uhl. These three natives of Spotswood spent many hours sharing their old family photographs and relating the tidbits of life that became the captions of this book.

The individuals who provided photographs and historical input to this book include the following: Patricia Brown and the rest of the Brown family; Gary Castellano; Ann Corrado; Albert Hall; Edward Horter; Henry Jensen; Dottie Klekner; Erma Lohr; Harvey Lohr; Vernon Lohr; Bertha Luczkow; Elizabeth Mark; Patricia McKenna; Frank Nicastro; Marie Nicastro; Shirley Murphy; Craig and Irene Niediemeir; Barbara Rasmussen; Gary Restivo; May Riffenberg; Ada Schellenberger; Charlie Verasca; and Stuart Zagnit. Members of St. Peter's Episcopal Church provided materials as well.

We also want to thank our wives, Patricia Dey and Karen Brady-Eckman, who graciously cooperated with their husbands in the many hours it took to complete this project.

We hope this book will acquaint current residents of the borough with the history of our quaint little town.

Bruce Eckman
Jack Eichenlaub
Roy Dey Jr.

INTRODUCTION

In the 17th century, the land that was to become New Jersey was divided into two distinct colonies. Spotswood lies in the section that was referred to as East Jersey. East Jersey was owned and governed by a board of proprietors. James Johnstone, the first European settler of Spotswood, was a proxy member of the governing board. Johnstone's political views fortunately differed from the king's. He immigrated here to save his own neck. Johnstone initially settled on Emboyle Point (Perth Amboy), but a good land deal drew him to our area.

On April 10, 1685, the board of proprietors purchased from the local Native Americans the land west of the South River, calculated at 8,000 acres. The land ran back from the river more than two miles and approximately six miles along the river. This purchase was divided into 500-acre lots, each having a half-mile fronting the river. The common land lying between these lots and the partition line (the line separating East and West Jersey) was to be laid out for servants of persons taking out patents (property rights) for the land fronting the river. James Johnstone took a patent out for the land covering the center of town. He also imported a number of servants: Margarett Welch, Margarett Eubb, Alex Adams, William Mountt, John English, John Gibb, George Ford, and Robert Moure. Each indentured servant entitled Johnstone to patents and an additional 100 acres. Johnstone took out five patents for the area known as "the hylands," across the Burlington path (now known as Clover Estates). He took a patent for his brother John Johnstone, trying to entice him to immigrate here. James Johnstone was successful; in 1685, Dr. John Johnstone sailed from Scotland with his bride-to-be, Euphernia Scot. They arrived at Emboyle Point, where they settled. John Johnstone died on September 7, 1732. Among the residents listed in records between 1760 and 1792 were David Carnegie (Lord Rosehill), John Lewis Johnston, James Rue, Samuel Neilson, Davis Stout, Richard Lott, James Abrams, James Perrine, and John Perrine.

As for James Johnstone, no one knows what happened to him. He did, however, give Spotswood its name. Johnstone came from the Scottish village of Spotteswoode. His plantation in the New World took his name.

On February 26, 1908, a meeting was held at Spotswood, which had been since 1860 a part of East Brunswick Township that had separated from Monroe. Spotswood was free to consider incorporating the town as a borough because the Monroe farmers wanted a dry community, free from taverns and hotels. On April 15 of that year, with a population of fewer than 800, the borough was created. It was carved out of the southeast border of East Brunswick, near the mouth of the Matchaponix, and was a station on the Camden and South Amboy branch of the Pennsylvania Railroad, about 11 miles south of Perth Amboy.

Election of officials to conduct the affairs of the borough soon followed at the old firehouse. In June 1908, the first council meeting was held in the firehouse, which then became known as the borough hall. Rev. Francis Smith, then rector of St. Peter's Episcopal Church, opened

the meeting with a prayer. Peter F. Daly, master in chancery of New Jersey, swore in Arthur B. Appleby, a staunch Democrat, as Spotswood's first mayor. Appleby served as mayor until 1914. He also served as president of the local board of education, and it was under his leadership that the four-room brick school on Main Street was erected in 1901 and the educational system was placed on a firm foundation. The school later became the Margaretta M. Birchall School. It closed its doors in 1979. Appleby also served as sheriff of Middlesex County for a short term.

The original council was composed of William J. Bissett, Augustine Cornell, Augustus DeVoe, Hamilton Hazlehurst, Joseph Hodapp Jr., and T. Francis Perrine. Thomas J. Brown was selected to be the borough's first assessor, and John H. Dill was its first collector. Robert W. Helm, notary public of New Jersey, swore Peter F. Daly into office as borough attorney on June 10, 1908.

George W. DeVoe became borough clerk, and Phines Mundy Bowne, a justice of the peace, was named recorder. Bowne, also an ardent Democrat, was elected second mayor of the borough, serving from 1914 to 1915. Upon retirement from the office of mayor, he was appointed borough clerk by subsequent mayors, both Democrats and Republicans. He resigned in 1946 at the age of 93, following 32 years of service as clerk. Earl G. Sparks succeeded him. Bowne also served as registrar of vital statistics, an office he held until his death in 1949.

Other appointments made in 1908 included marshals John McCumsey, Clarence Burchall, and John P. Applegate. Edward Beebe was named pound keeper. Joseph Hodapp Sr., Dr. Charles Massinger, John J. LaRue, John Rothar, and Harry C. Kitchen were appointed to the board of health. In 1909, John O. Cozzens became a councilman. He also served as president of the board of education for many years. With the election of J. Randolph Appleby Sr. as mayor in 1917, Spotswood had its first Republican mayor. Peter J. Schweikert, a Democrat, followed him in 1919. In 1921, Charles DeVoe, a Democrat, succeeded his cousin as mayor.

E. Raymond Appleby, son of the third mayor, became mayor in 1925. He later served as borough commissioner, president of the board of education, borough councilman, and assessor. Nelson E. Jolly, a Democrat, became mayor in 1927 and served two terms. Charles Siegel succeeded him in 1931 and served into the 1960s. The next mayor was Russell F. Kane, a Republican, who succeeded Siegel and served through much of the 1960s.

When Spotswood became a borough, it was a placid little community, ranging for the most part along Main Street, which was lined with tall old trees. Comfortable wood-frame houses were built on spacious grounds. Almost everyone had a vegetable garden and kept a few chickens, a horse, and even a few pigs. During the industrial growth of the 20th century, several factories came to Spotswood, replacing the tourist-based economy by the 1930s. With the growth of industry, the demand for housing grew, and much of Spotswood's open space became housing developments. As the population grew, commercial consumer businesses and professional services prospered in the borough.

One
MAPS

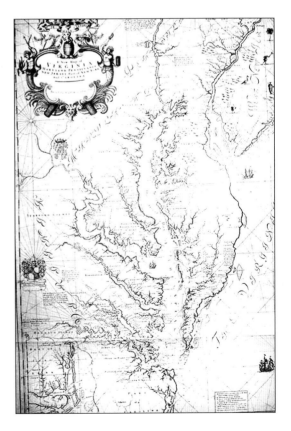

John Reid's map shows the southern tip of Jersey, part of West Jersey, and Virginia. New Jersey was divided into West Jersey and East Jersey. As a young colony developed, Spotswood, stretching along what was known as Lawries' Road and featuring a few business establishments, became something of a village center for surrounding farms. It was also known as an overnight stop on the stagecoach that went from New York to Philadelphia via the Amboys.

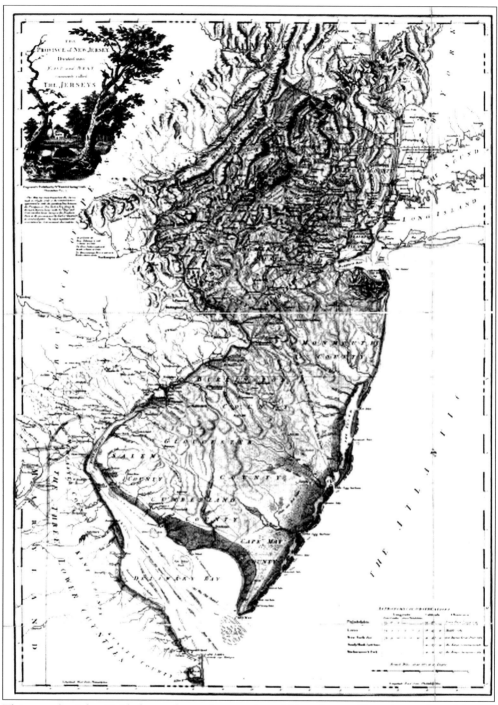

This map by John Reid shows the early counties of New Jersey. Counties such as Mercer, Atlantic, and Ocean were not yet in existence. The town's first white resident, James Johnstone, arrived from Scotland, naming his new home after his old one, Spotteswoode. The territory owned by Johnstone extended into what is now known as Monmouth Battlegrounds.

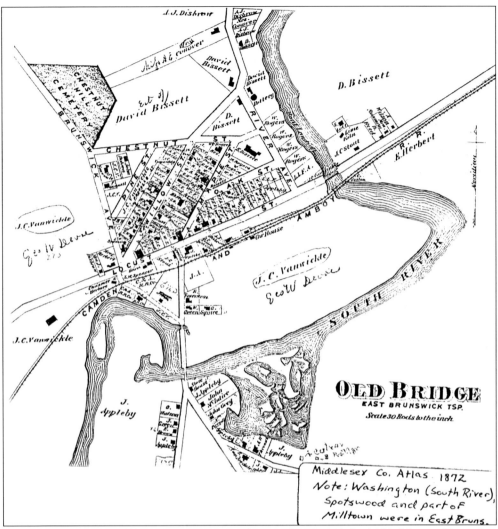

This map from the Middlesex County map archive is dated 1872. In 1838, Monroe Township broke away from South Amboy, which was then a large municipality, taking Spotswood with it. In 1860, East Brunswick broke away from Monroe, and Spotswood went along again.

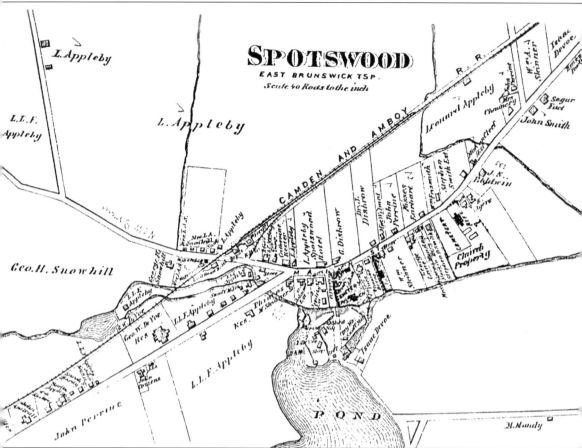

This map is a survey of property ownership of the founding families of Spotswood in 1872. For some time between 1800 and 1881, Daniel, Andrew, and George Snowhill; John, William, and Leonard Appleby; Isaac and Augustus DeVoe; Phineas, William, and Lewis Skinner; John and William Dill; William Perrine; John Outcalt; John Browne; and George W. Helme all were extensively engaged in snuff manufacturing. Shirts, hominy, and a variety of other products were also manufactured in the borough at one time. Many local streets bear the names of these manufacturers.

Two
CHURCHES

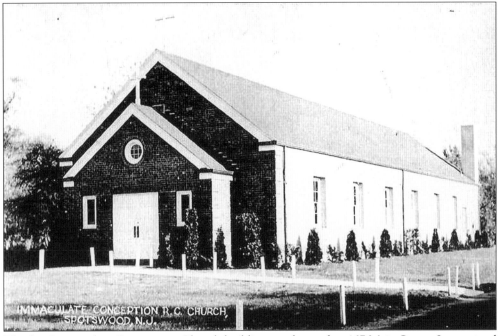

The first Immaculate Conception Church building was located at 467 Main Street. It remained on that site until its parish outgrew the space in the 1960s. The Spotswood Greens Apartments now sit where the church structure was located, and the Verizon switching station sits where the old parish hall was located. At its founding in 1908, Spotswood had three taverns, all on the north side of Main Street, which became known as "the Devil's side" of the street. The south side was home to three churches, including the Immaculate Conception Church, and became known as "the Lord's side."

Immaculate Conception Church is seen here in 1960. The church had outgrown its Main Street structure and moved to the site of the old Hazelhurst estate on Manalapan Road. The new facility included a grammar school that served kindergarten through grade eight. It was the borough's first private educational institution. The school housed a large auditorium-cafeteria, and the parish made this facility available for social and sporting events for all residents of Spotswood.

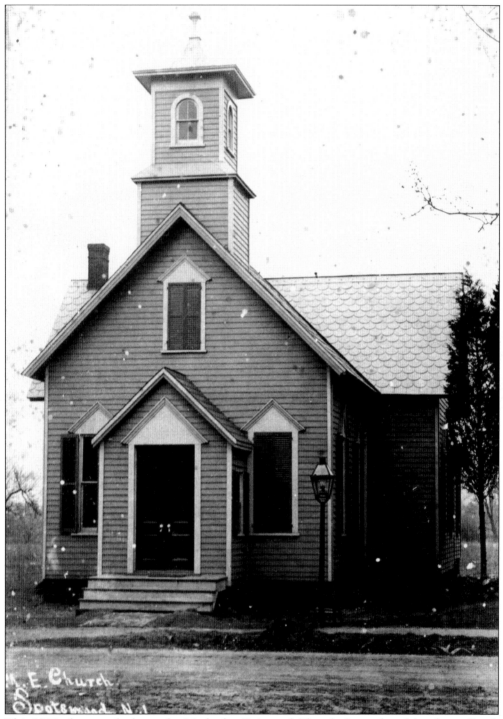

This 1903 photograph shows the Methodist Episcopal Church, located on Manalapan Road. The original wooden structure was located across from the brick structure that serves the congregation today. The original building was erected in the 1800s and survived until it was destroyed by fire in the 1950s.

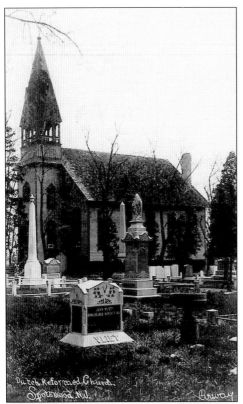

Located on Main Street across from the post office, the Reformed Church graveyard is the site of the final resting place for many members of the early prominent families of Spotswood, such as the DeVoes, the Vliets, and the Applebys. The building shown here was erected in 1866, but the congregation was in existence as early as 1821.

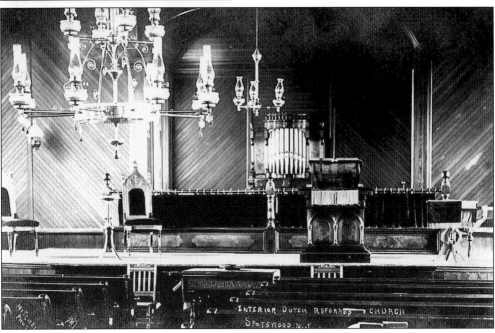

The Reformed Church, under the leadership of Rev. Joseph Woods, expanded its activities to include the Pixie Preschool and the Woodmere and Crescent Park senior citizen housing facilities. It is one of the churches on "the Lord's side" of Main Street.

Seen here is the Spotswood Reformed Church in 1950. After World War II, the church began a yearly tradition of putting on fall ham dinners, with postmaster Harvey Uhl serving as the chief cook. Uhl could be seen running back and forth between his chef duties and his regular job as the borough postmaster. Social life in Spotswood has always been closely linked to religious organizations and their churches.

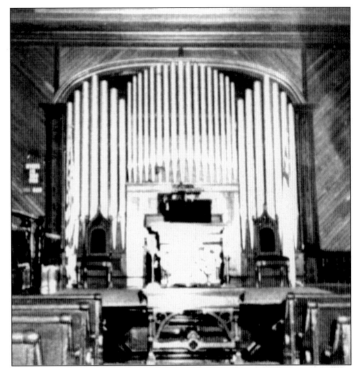

The Spotswood Reformed Church parsonage appears in this 1950 photograph. Peter Markey was the pastor of this church in the 1950s and 1960s; Rev. Joseph Woods succeeded him. Its adjacent cemetery is one of only two located in the borough and is the resting place of many of those mentioned in this book, such as Vincent Woodmansee and William Hunn.

St. Peter's Episcopal Church is one of the oldest churches in the diocese of New Jersey. The parish was organized in 1756; Anglican services were conducted prior to 1704. Missionaries were sent from England to New Jersey by the Society for the Propagation of the Gospel. In the first decade of the 18th century, 30 families around the village of Spotswood decided to establish a parish of their own. A missionary report dated 1758 described the church as a "handsome wooden church in a small village called Spotswood." The first recorded vestry minutes were dated August 1761.

This photograph depicts the wedding of Peter Rasmussen and Barbara Lettau at St. Peter's Episcopal Church. They were married by Fr. John DuBois. Peter Rasmussen later became the branch manager of the First National Bank of Spotswood. Some of the graves in the church's cemetery date from as early as 1690. Until recently, church clergy lived in the rectory with their families. The rectory now houses the church offices.

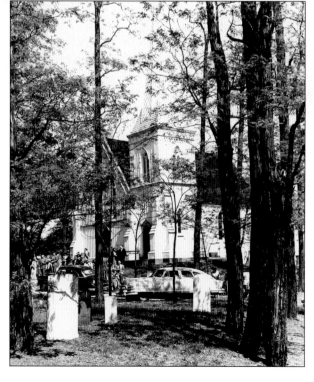

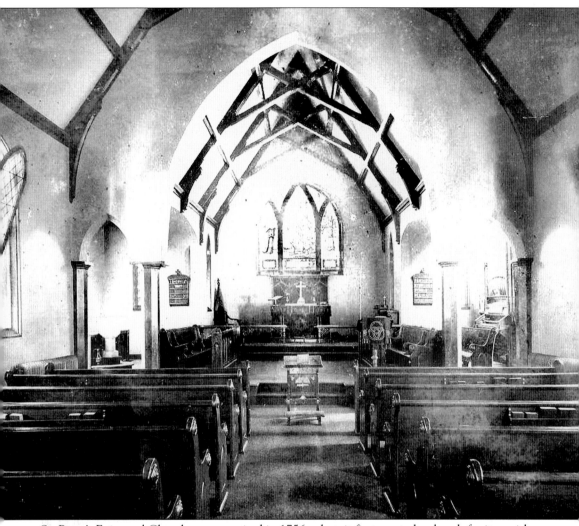

St. Peter's Episcopal Church was organized in 1756, when it first erected a church for its parish. In 1848, the vestry learned that the original church building was unsafe. A new church was built in 1854. In the early 1990s, the church underwent extensive renovations. The steeple was removed for a period of five years as funds were raised for its repair. During this period, a time capsule from the 1890s was discovered.

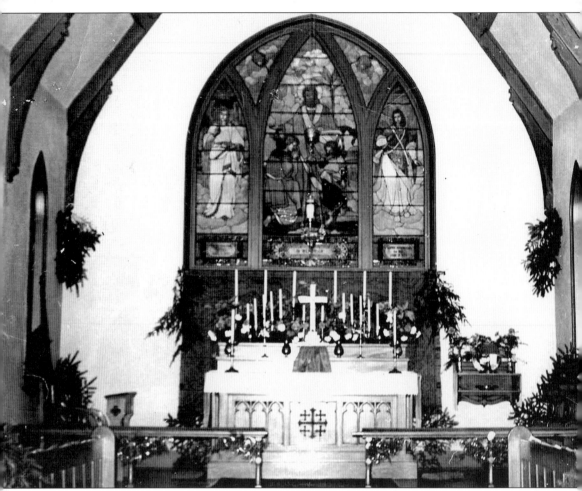

In 1896, extensive alterations were made to St. Peter's Episcopal Church. The chancel was deepened seven feet, enlarged on the south side for the organ chamber, and enlarged on the north side for a baptistery. A basement was also dug for a steam heater. New pews and carpet were installed, as well as stained-glass windows. The chancel window is a DeVoe family memorial, and the baptistery window is a Rapoyle family memorial. When the church reopened, it had its first vested choir of men and boys. In 1920, an altar was given by the congregation in honor of World War I solders. This altar is currently used in the Children's Chapel.

Three
SCHOOLS

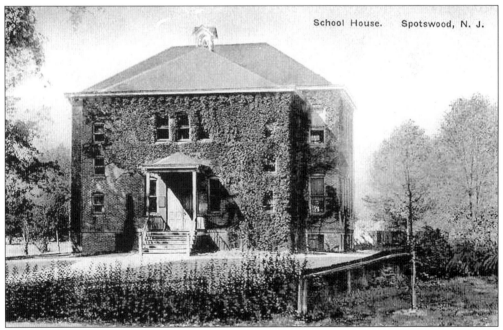

School House. Spotswood, N. J.

The Spotswood Public School was constructed in 1901 and was later renamed to honor longtime teacher Margaretta M. Birchall. It stood on Main Street across from St. Peter's Church and was in use until the early 1970s.

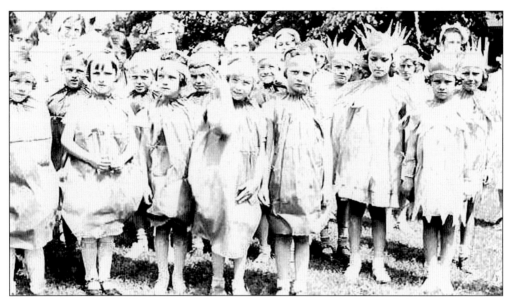

Shown here is the 1937 May Day celebration featuring a maypole dance, children dressed up as sunbeams, and other niceties of spring. Note that no children are wearing long pants; the boys in the second row are sporting knickers.

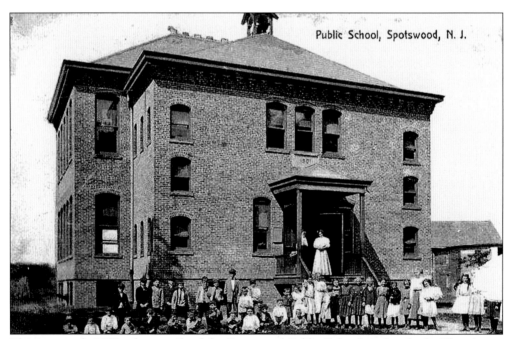

This is an early-1900s photograph of the Spotswood Public School student body. The picture shows the original school structure. The building was expanded several times during the 20th century as the student population grew. In the early days, children shook chestnuts from trees for snacks.

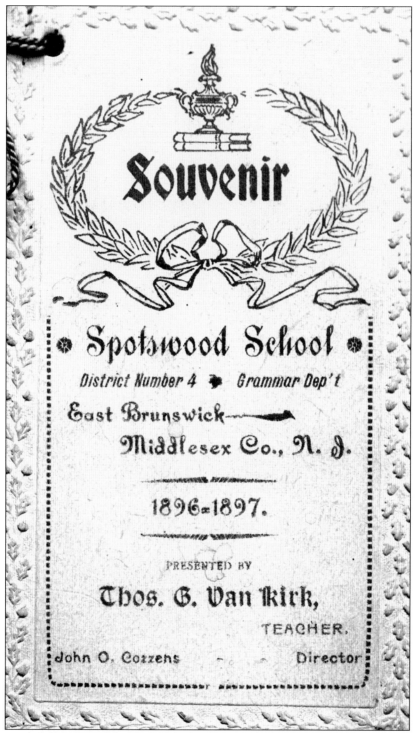

Souvenir

● Spotswood School ●

District Number 4 ✿ Grammar Dep't

East Brunswick

Middlesex Co., N. J.

1896=1897.

PRESENTED BY

Thos. G. Van Kirk,

TEACHER.

John O. Cozzens — Director

The Spotswood Grammar School served 185 students. Anna Fitts served as principal. In the early 20th century, Spotswood had a population of 700, most of whom were employed in local mills or in supporting the work of the surrounding farms.

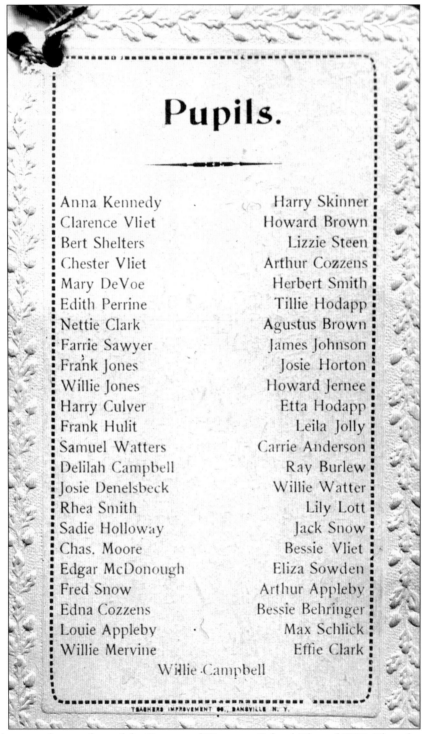

Pupils.

Anna Kennedy	Harry Skinner
Clarence Vliet	Howard Brown
Bert Shelters	Lizzie Steen
Chester Vliet	Arthur Cozzens
Mary DeVoe	Herbert Smith
Edith Perrine	Tillie Hodapp
Nettie Clark	Agustus Brown
Farrie Sawyer	James Johnson
Frank Jones	Josie Horton
Willie Jones	Howard Jernee
Harry Culver	Etta Hodapp
Frank Hulit	Leila Jolly
Samuel Watters	Carrie Anderson
Delilah Campbell	Ray Burlew
Josie Denelsbeck	Willie Watter
Rhea Smith	Lily Lott
Sadie Holloway	Jack Snow
Chas. Moore	Bessie Vliet
Edgar McDonough	Eliza Sowden
Fred Snow	Arthur Appleby
Edna Cozzens	Bessie Behringer
Louie Appleby	Max Schlick
Willie Mervine	Effie Clark
Willie Campbell	

TEACHERS IMPROVEMENT CO., DANSVILLE N. Y.

Listed here are the members of the Spotswood Grammar School Class of 1897. The school, later renamed after Margaretta M. Birchall, was built c. 1890. The students include descendants of the founding fathers of the borough.

24

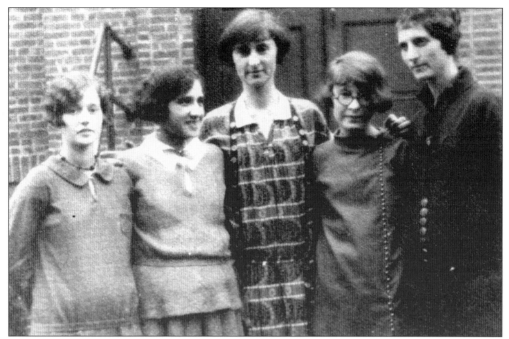

This 1930s photograph of the Spotswood school staff shows, from left to right, unidentified, Katherine Ortel-Ross, Hester Michael, unidentified, and Margaretta Birchall.

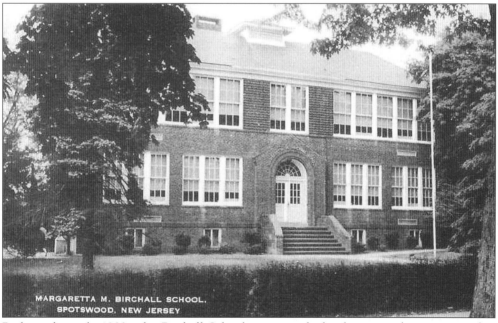

MARGARETTA M. BIRCHALL SCHOOL.
SPOTSWOOD, NEW JERSEY

Built in the early 1900s, the Birchall School was named after longtime elementary teacher Margaretta M. Birchall. Later found to be unfit to serve as a school building, the structure served as the board of education's administration offices until it was sold in 1985 to Grace Hydrusko. Hydrusko operated her bus service, with an 85-bus fleet, from the building for several years. The land was sold to a private developer in 1998, and the building was demolished in August 1999.

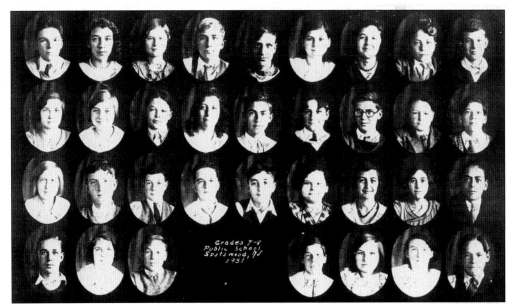

This 1931 photograph shows the eighth-grade graduating class and the seventh-grade class of the Spotswood Public School. From left to right are the following: (first row) Nelson Jolly, Edna Schab, Violet Surowiec, Casimer Sierp, Thomas Baranek, Josephine Kokoszka, Haletta Evans, Walter Sierp, and Christian Osterburg; (second row) Evelyn Lettau, Hilda Osterburg, Charles Flanagan, June Kiotz, Charles Firestein, Al Chitren, Roland Turner, Harvey Reilly, and Charles Glock; (third row) Elizabeth Johnson, Herbert Buhrle, Joe Dunn, LaRue Thomas, Will Landesman, Sarah Schwartz, Louie Rodgers, Sophie Firestein, and George Laut; (fourth row) Harold Rigler, Veronica Kilroy, Clarence Beebe, Harry Hyde, Josephine Shutz, Ruth Rigler, and Charles Taskowitz.

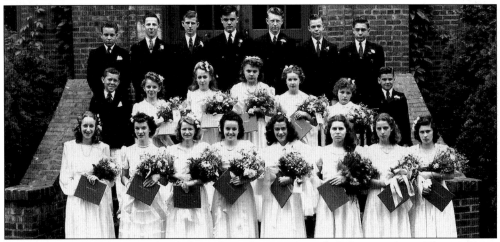

The Spotswood Public School eighth-grade graduating class of 1945 is seen here. The graduates are, from left to right, as follows: (front row) Dorothy Hall, Nancy Jolly (Dougherty), Jean Szymanski (Gretch), Jean Shelters, Barbara Lettau (Rasmussen), Mary Hunt, Thelma Bennett, and Dolorus Platt; (middle row) Robert Horvath, Theresa Novak (Bromley), Lois Waitley, Mary Herzig, Marilyn Magee, Audrey Perrine, and Raymond Geiple; (back row) Donald Dawson, Eugene Scheicher, Frank Choinacki, Joseph Reil, William (Red) Moran, Robert Dougherty, and James Pollen.

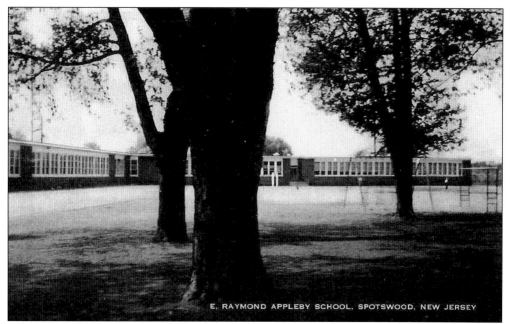

E. RAYMOND APPLEBY SCHOOL, SPOTSWOOD, NEW JERSEY

The Appleby School was constructed in 1955 and named after E. Raymond Appleby. Appleby served the borough as a commissioner and member of the board of education for many years. The school was the second public school built to accommodate the baby boomers. The school was constructed to accommodate the adjacent Little League baseball field. After many windows in the school were broken, the field was moved to its present location on Jackson Street.

Seen here is the Spotswood High School. Prior to the 1970s, Spotswood students attended the South River High School. South River asked Spotswood to leave its schools as a cost-saving measure. Spotswood decided to build a high school rather than seek another receiving district. The school is located on Summerhill Road. Spotswood soon became a receiving district for students from Milltown and Helmetta. The school experimented with open-style classrooms, but the concept proved to be a failure and led to the redesign of the interior of the building into conventional classrooms.

27

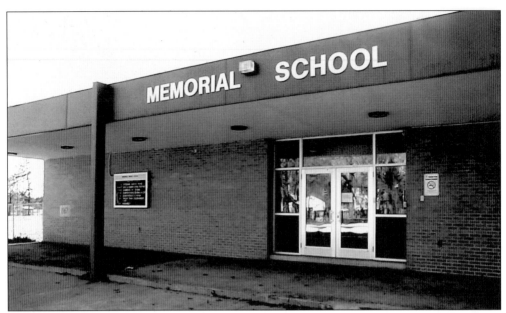

The Memorial School was the fourth school to be constructed in the borough and the first to have a gymnasium. When the student population began to drop, the school was rented to the South Amboy Board of Education. South Amboy then bused in students daily for many years. The school currently functions as the middle school for the borough, serving the sixth, seventh, and eighth grades. Many borough groups use the gymnasium for various recreational purposes.

The Schoenly School opened in the late 1950s and was named after G. Austin Schoenly, a longtime principal of the Appleby and Birchall Schools. The school was primarily built to accommodate the students of the newly constructed Clover Estates development. The school now serves students in kindergarten through second grade.

Four
COMMERCE

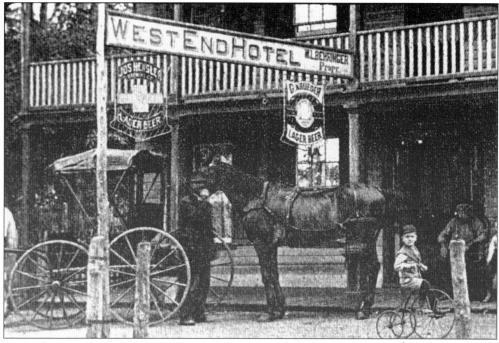

In the late 1800s, the proprietor of the West End Hotel, M.L. Behringer, served his thirsty travelers G. Krueger lager beer and Joseph Hensler lager beer. In this view, note that the automobile has not yet come to Spotswood. The horse-drawn buggy was the typical mode of transportation. The local commercial enterprises of the 18th and 19th centuries included sawmills, tanning mills, snuff mills, a distillery, blacksmith and wheelwright shops, general stores, clothing factories, warehouses, and inns for the numerous travelers.

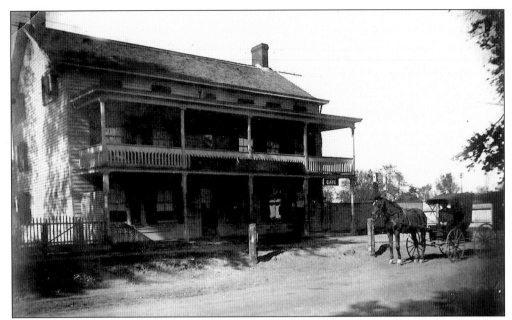

The West End Hotel was located on Manalapan Road, the present-day site of the Methodist Church. It served as the first night's layover for coach travelers going south from New York to Bordentown and Trenton. The building was of all-wood construction, in which wooden dowels such as those employed in shipbuilding were used.

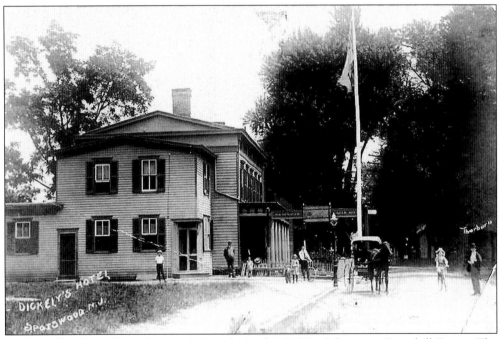

Dickely's Hotel was located west of the present-day DeVoe Library on Snowhill Street. The hotel advertised its own "pure spring water" and was "opposite the Pennsylvania Railroad Depot." The hotel was said to attract big-city folk with the pleasures of country living.

Seen here is a Dickely's Hotel advertisement. George Dickely, proprietor, boasted of his first-class livery and first-class accommodations, with lighted gas lamps powered by his own plant. The hotel was one of the first buildings in town with a telephone connection. Reflecting its rural surroundings, the hotel offered recreational activities that included boating, fishing, and hunting. This advertisement came from Violet Hulit, who was a longtime resident and parishioner of St. Peter's Episcopal Church.

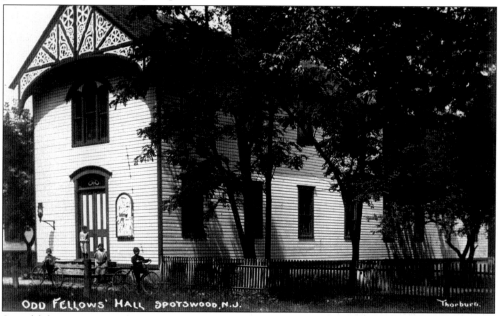

Social life in Spotswood was closely related to the churches. Odd Fellows Hall, also known as Whitney Hall, was the center of other social activities, with lodge meetings held there several nights a week. The Red Men, the Odd Fellows, and the American Mechanics held their meetings there. Occasionally a dance was held there, and several medicine shows played there every year. The school commencements were also held in the hall.

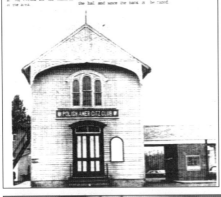

Is Spotswood Landmark Hall To Become Thing of The Past?

SPOTSWOOD — Has one of this borough's landmarks outlived it usefulness? Is it soon to become a thing of the past?

This question is being asked about the Polish-American Hall in Main St. The more than 50-year-old structure is still in good condition. Until its purchase by the Polish-American Club it was known as Whitney Hall and was for many years the only hall available for social events and many dances were held there during the early part of the century.

It was also the site for regular weekly meetings of such fraternal organizations as the Odd Fellows, Osage Tribe of Red Men, American Mechanics and Royal Arcanum and many mysterious rites were held in the upper chambers of the hall during initiation ceremonies.

Once or twice a year motion pictures were shown there and at times there were silent movies and big events for the children in the area.

The Woman's Club, St. Peter's Sunday School, and other groups presented plays there and there were musicals show presented by Herman B. Lettau Post American Legion and the Parent-Teacher Association.

The old hall was also the scene of a Grand Dance held April 1, 1920, by the Welcome Home Committee in honor of the returned service men from World War I.

For many years school commencements were held there and there have also been wedding receptions and communion breakfasts, dinners and card parties.

The two story building has meeting rooms on the second floor, the main floor is the hall complete with stage and dressing rooms and the basement houses a bar and kitchen facilities.

The Spotswood branch of the First National Bank of Middlesex County is located next to the hall and since the bank is interested in expansion, it has contracted for the purchase of the hall with the agreement that the Polish American Club be permitted to use it until their new hall has been completed.

Joseph Kirk, president of the bank, when asked what will be done with the building, said, "Anyone who wants it may have it intact. We have no definite plans at present but need room for driveways and intend to beautify the area by landscaping it."

The Polish-American Club has purchased a 2.4 acre tract on the east side of Adirondack Ave. north of the Snowhill St. intersection. The club has been granted a subdivision and work has been started on construction of its new clubhouse.

It should not be many months before the club vacates old Whitney Hall and after that, if no one wants to move it to another site, it will probably be razed.

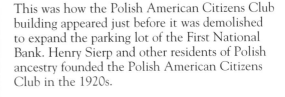

This was how the Polish American Citizens Club building appeared just before it was demolished to expand the parking lot of the First National Bank. Henry Sierp and other residents of Polish ancestry founded the Polish American Citizens Club in the 1920s.

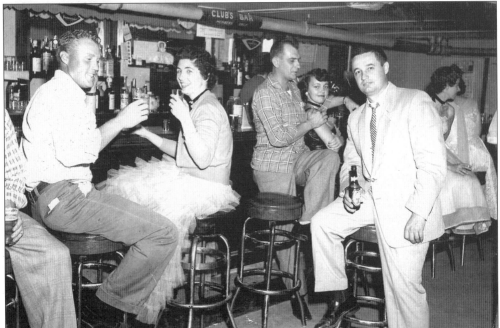

The Polish American Citizens Club was located on Main Street. The bar pictured here was located in the basement and was the scene of many social events. From left to right are Robert (Buddy) Snure, Marie Snure, Scott Edwards, Dorris Edwards, and Steve Kumka.

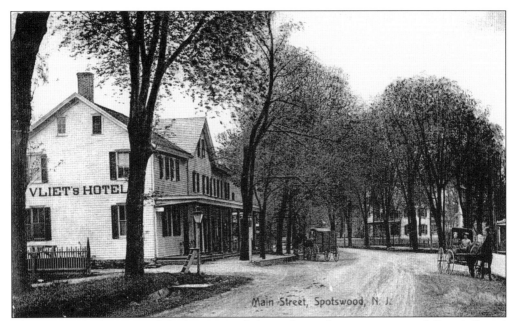

This view of Vliet's Hotel looks eastward from about the intersection of Snowhill and Manalapan Streets. The unpaved condition of Main Street indicates that the picture was taken c. 1900. On the west side of the hotel is the present-day Vliet Street, which up until the 1930s was a direct continuation of DeVoe Avenue. DeVoe Avenue was realigned to its present-day orientation after DeVoe Lake was enlarged as part of a Work Projects Administration initiative.

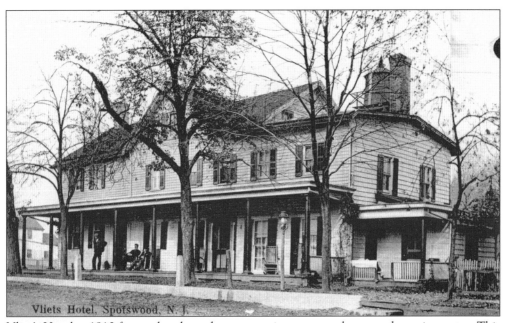

Vliet's Hotel c. 1910 featured such modern conveniences as gas lamps and running water. This water supply came from the hotel's own dedicated water tower constructed of wood. The borough's modern municipal water supply did not begin operating until the 1930s. Note the concrete curb and hitching posts in the foreground of this view.

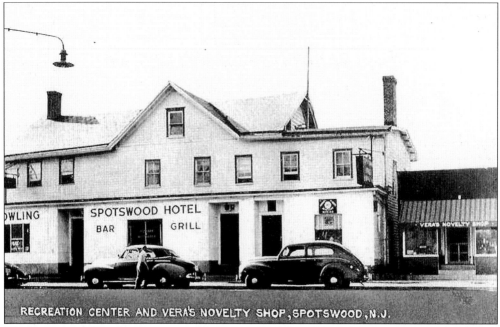

RECREATION CENTER AND VERA'S NOVELTY SHOP, SPOTSWOOD, N.J.

The Spotswood Hotel once sat on the corner of Vliet and Main Streets. It ceased to house travelers at an early date, but it did house a bowling alley, a bar and grill, and a sporting goods store. This enterprise was originally known as Vliet's Hotel. Many young boys worked in its bowling alleys as pinsetters. In this 1940s photograph, paved streets, sidewalks, and electric streetlights have come to town.

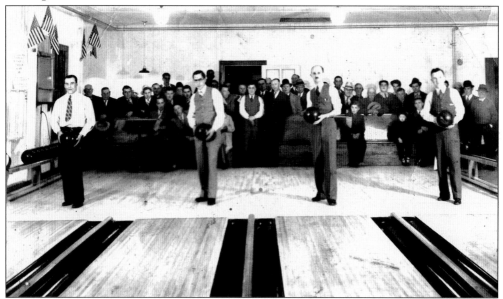

Seen here is the Spotswood Hotel and Bowling Alley on April 17, 1937. The bowlers are, from left to right, Kenneth Hodapp, Robert Mott, William Goldsmith, and George Siegel. Sitting on the bench behind Siegel, who was then serving as mayor, is five-year-old Jean Szymanski Gretch and her father Joseph Szymanski. Standing in front of the main entrance is Walter Burgess, owner of the hotel and bowling alley.

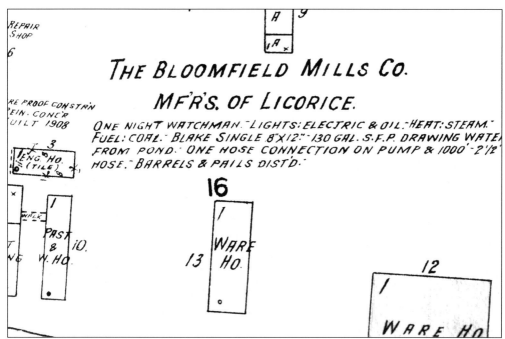

REPAIR SHOP
6

RE PROOF CONSTR'N
'EIN. CONC'R
'UILT 1908

ENG. HO.
(TILE)

THE BLOOMFIELD MILLS CO.
MF'R'S. OF LICORICE.

ONE NIGHT WATCHMAN. LIGHTS: ELECTRIC & OIL. HEAT: STEAM.
FUEL: COAL. BLAKE SINGLE 8"X12". 130 GAL. S.F.P. DRAWING WATE[R]
FROM POND. ONE HOSE CONNECTION ON PUMP & 1000' 2½'
HOSE. BARRELS & PAILS DIST'D.

16

1
WARE HO.

13

PAST
& iO.
N'G W. HO.

12

1

WARE HO[USE]

This early blueprint shows the lay of the land when the mills of the Bloomfield Mills Company were constructed. The document was probably created to communicate information necessary for the local fire-prevention authority. Note the references to fireproof construction and various methods available to deliver bulk quantities of water to a fire on site. One night watchman was available to handle off-hours emergencies.

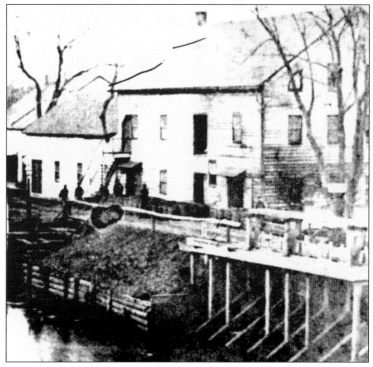

The old licorice mill of the Bloomfield Mills Company had a wooden dam that was used to supply power to the machinery in the factory. The mill was abandoned in the 1920s. Licorice root was piled up five feet high around the abandoned building. This root caught fire and smoldered for two years. Some remnants of the old structure still remain.

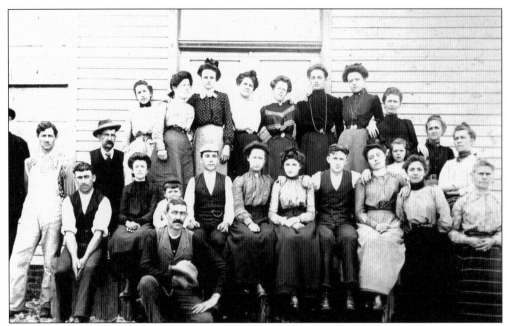

Seen here are workers employed at the Bloomfield Mills Company. Note that the plant labor force appears to be largely composed of women. The mill produced black licorice, thought to be especially good as a remedy for the common cold.

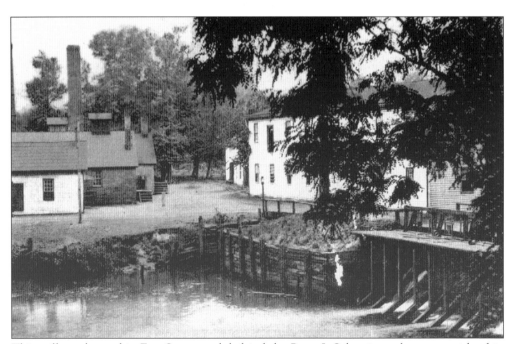

This mill was located in East Spotswood, behind the Peter J. Schweitzer plant on an island in present-day Duhernal Lake. The island was connected to the mainland by a wooden bridge.

Seen here is an advertisement for one of the many products produced at Eagle Mills. Note that the mill was owned and operated by members of two of the borough's oldest and most prominent families, the Applebys and the DeVoes. As the years went by, the Spotswood mills gradually converted to making other products as cigarettes replaced snuff use. These firms also traded under the name of Pocahontas Mills.

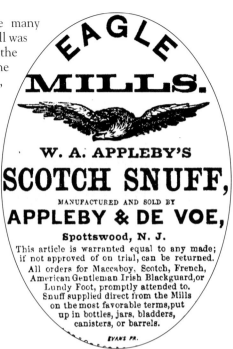

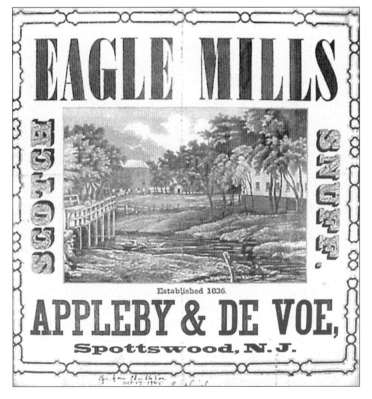

Owned and operated by Appleby and DeVoe, Eagle Mills was the leading commercial enterprise in Spotswood. Notice the spelling of Spotswood.

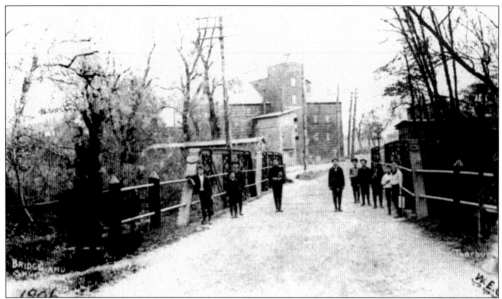

This bridge spanned the Manalapan Brook and is now known as DeVoe Avenue. Note that by 1906, when this picture was taken, a metal bridge had replaced the wooden structure. The large building in the background was known as the Old Red Mill. This photograph was taken two years before the incorporation of the town.

The street where the DeVoe Avenue Bridge is located appears to have had at least three names over the years: Bridge Street, DeVoe Street, and now DeVoe Avenue. Records indicate that long before the American Revolution, members of the Perry, Cohen, and Hayes families were living on the property depicted in this photograph. During their tenure, a forge was operated on the site.

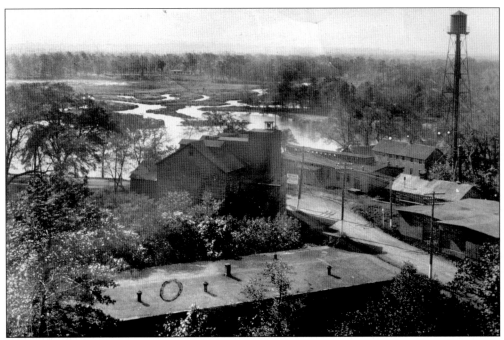

This is an early view of the Appleby DeVoe Eagle Mills. This picture was taken from the steeple of St. Peter's Episcopal Church. It shows the property now occupied by the Spotswood First Aid Squad and the American Legion. Notice the For Sale sign in front of the building now occupied by the American Legion. The body of water pictured here was created by the paddle wheel driving the mill and did not cover an area as large as the modern lake. DeVoe Lake, as it is known today, was created for flood control as a Work Projects Administration initiative during the Great Depression.

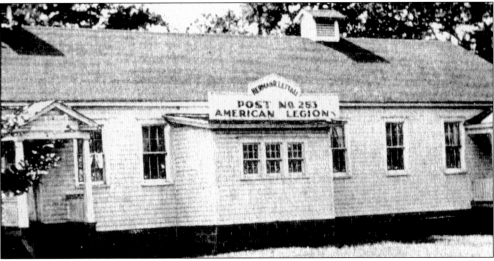

American Legion Post No. 253 was named after Herman R. Lettau, who served as councilman during the early years of Spotswood. This is the last standing structure of the old Appleby DeVoe Eagle Mills in Spotswood. The property now belongs to the borough of Spotswood and was leased to the American Legion for a nominal fee. This site is part of the lake recreational area.

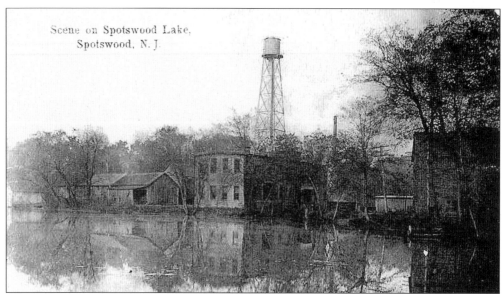

This view shows the Appleby DeVoe Eagle Mills from the lake. Water flowed rapidly under the building shown on the right, spinning a paddle wheel and thus providing power for the mill and other operations. The modern-day concrete dam is visible on the left.

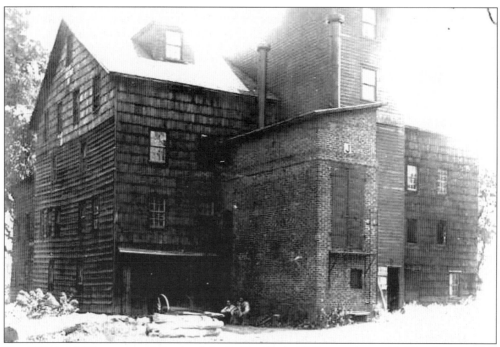

The Old Red Mill was part of the Appleby DeVoe Eagle Mills complex on DeVoe Avenue, just south of Main Street. Tobacco leaves were dried in the brick substructure at the front of this complex. It was built of brick instead of wood in order to minimize the risk of fire during the drying operation, which involved the direct combustion of wood. This facility was originally owned by the Skinner family. It manufactured paper and printed Continental currency during the American Revolution.

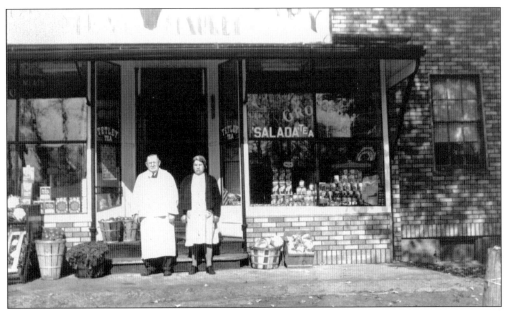

The Spotswood Sanitary Meat Market was located at the intersection of Main Street and DeVoe Avenue at 520 Main Street. The second owners were Morris and Fannie Shapiro, who settled in Spotswood in the early 1900s. The Shapiros operated the store (later known as the Main Street Market) until 1945, when they retired. The Shapiros' daughter and son-in-law, Gladys S. Zagnit and Alvin Zagnit, along with their son Harold Shapiro and his wife, Lillian Shapiro, ran the establishment until 1961, when the store was closed.

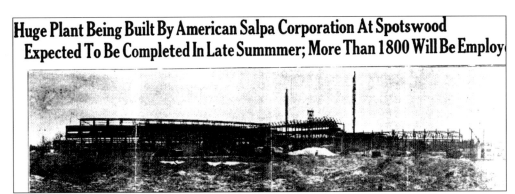

With the closing of the snuff mills, local industry was at a standstill for a time. The leaders of Spotswood recognized that the town needed industry to survive. As a result of their efforts, the American Salpa plant was constructed in 1929 at a site located at the extreme east end of town. Spotswood beat out other local municipalities in a bid for the facility, due to its willingness to provide large quantities of water for this leather-reprocessing operation. This plant was owned by Italian nationals. It closed in the early 1930s, when the owners returned to Europe.

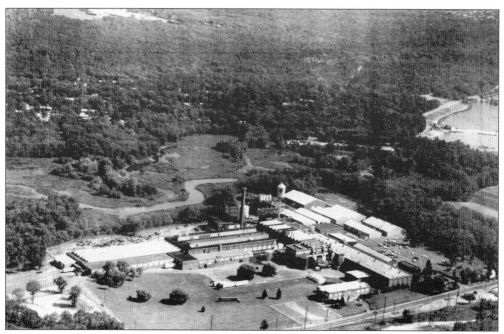

The American Salpa Corporation sold its plant, located in east Spotswood, to the Peter J. Schweitzer family in 1941. The Schweitzers had operated cigarette-paper factories in New Jersey since World War I at locations such as Elizabeth. This plant is one of the few cigarette-paper-producing facilities in the eastern United States. It has continuously operated three shifts since it opened. It has been one of the largest employers of Spotswood residents for decades and still is our largest taxpayer. For years, the reception after the borough Memorial Day parade was held in the Schweitzer private picnic grove.

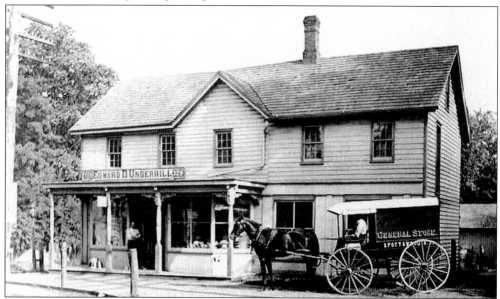

One of Spotswood's earliest food stores, the Underhill general store delivered food orders and other necessities of life to nearby farmers by means of a horse and carriage. The store was located on Main Street near the intersection of Summerhill Street.

Peter J. Schweikert owned and operated the Schweikert Sanitarium, located on the corner of Manalapan Road and South Street. The facility promoted good health and clean living. Schweikert was also active in politics and became one of Spotswood's mayors in 1919. This building was later purchased by the Immaculate Conception Church and served as its rectory for many years.

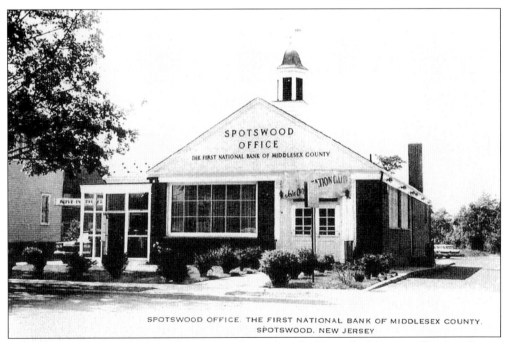

SPOTSWOOD OFFICE. THE FIRST NATIONAL BANK OF MIDDLESEX COUNTY. SPOTSWOOD, NEW JERSEY

The First National Bank of South River was located in the Hunn Building, at 482 Main Street. The business grew, and a new building was erected at 456 Main Street in 1955 (next to what is now the Flower Zone). Main Street residents were quite familiar with the bank's clanging alarm, which went off on a regular basis. (There has not been a robbery at the bank yet.)

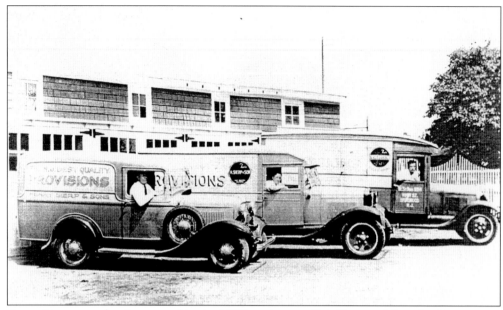

Henry Sierp moved to Spotswood in the 1920s and opened his Sierp and Sons food business at 268 Main Street. The garage pictured here still stands, and half of it now houses the Circle Janitorial Supply Company. The Sierps smoked meat behind this building in a small, white-brick smokehouse. Henry Sierp's daughter Sophie Sierp married Joe Martis, and they ran a grocery store on the corner of Kosciusko and Main Street for many years.

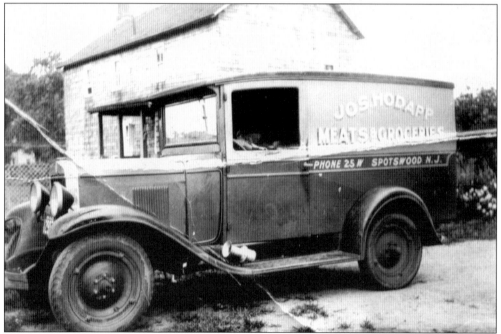

As the proprietor of an early meat-supply business serving Spotswood, Joseph Hodapp delivered his products to customers. Notice the siren mounted on the running board of the vehicle. Hodapp was a charter member of the Spotswood Fire Department. His son, Kenneth Hodapp, later ran a television and appliance business at several locations on Main Street.

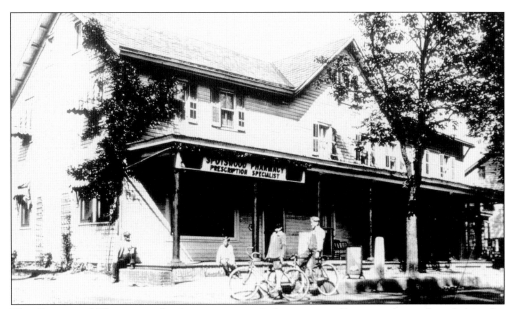

The Spotswood Pharmacy, the first commercial pharmacy in Spotswood, was founded in the post–World War II era in the building formerly known as Vliet's Hotel. Two brothers, Isadore and Melvin Singer, founded this business at about the same time that Dr. Cano, Dr. Ulan, and Dr. Bergen arrived in Spotswood to open their medical practices.

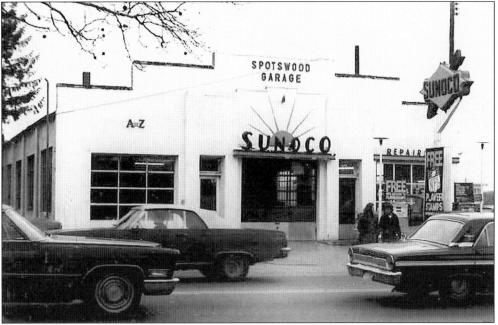

The Spotswood Sunoco station was located on Main Street where G & S Auto now stands. It has been owned and operated by the Shelters for most of the 20th century. This photograph was taken in the 1950s, when the gasoline business was so competitive that most dealers engaged in regular giveaways, such as the National Football League Player Stamps advertised on the banners visible in this image. The Sunoco station was a true full-service operation, offering oil changes and engine repairs.

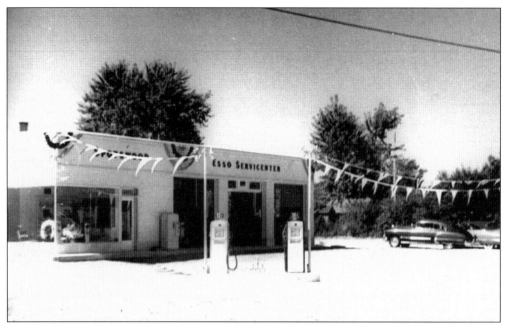

The Spotswood Esso station was located on the corner of Main Street and Summerhill Road. The business is now known as the Spotswood Exxon. This picture was taken for the business's grand opening in 1949. It was the second service station opened in the borough, after Hunn's garage at the corner of Main and George Streets.

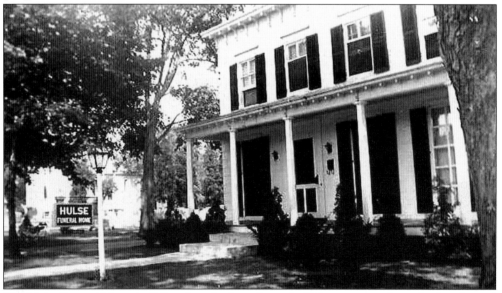

The Hulse Funeral Home building dates back to the early 19th century and was the first funeral home in Spotswood. It was located at 455 Main Street, where the present-day Reformed Church annex is now located. The funeral home opened in 1950 as a second site for the Hulse operation, which had been functioning in Englishtown for years. The first manager of this facility was William H. Eckman, who later founded Eckman Funeral Home in the former Immaculate Conception Church rectory at 475 Main Street. After his death in 1965, Alice Eckman ran the business for over 20 years.

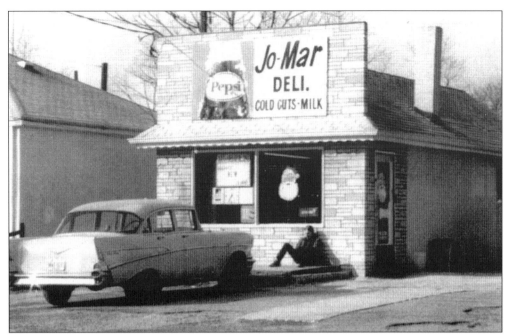

The Jo-Mar Deli was located on Manalapan Road across from John Street. It was purchased in the 1960s, and the name was changed Irene's Deli. Today, the business continues to serve the neighborhood as Ellie's Deli.

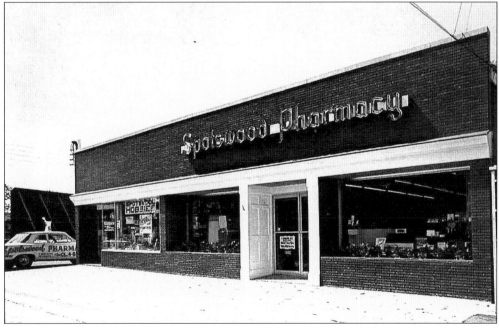

Located across from the town triangle on Snowhill Street, Spotswood Pharmacy was owned and operated by brothers Isadore and Melvin Singer. The Singer brothers constructed this building in early 1960. The Hobby Shop, a tenant of the building, was best known for its slot-car racing and miniature train displays. Eventually, Spotswood Pharmacy expanded to fill the entire building. Today Eckerd Drugs occupies the site.

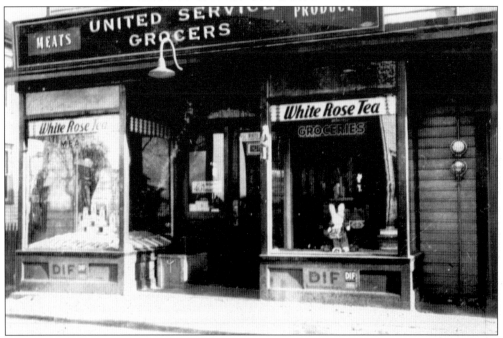

United Service Grocers was located on Main Street on the site now occupied by the Eckman Funeral Home parking lot. This property currently houses the Verizon switching station. The building pictured here was razed by the Immaculate Conception Church. In its place, the church constructed a parish hall.

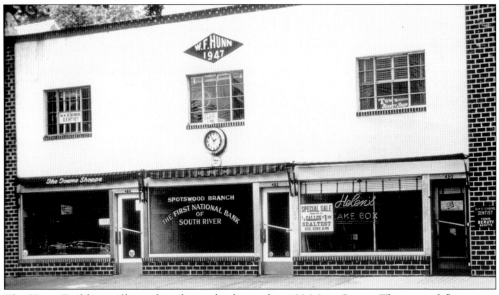

The Hunn Building still stands today and is located at 480 Main Street. The ground floor once housed the Towne Shoppe (a clothing and shoe store), the First National Bank of South River (its first location in Spotswood), and Helen's Cake Box (a bakery annex of Mendoker's Bakery in Jamesburg). On the second floor were a dentist, denture manufacturer, and other tenants. William Hunn was an early business leader in the community and managed a Ford dealership on Main Street.

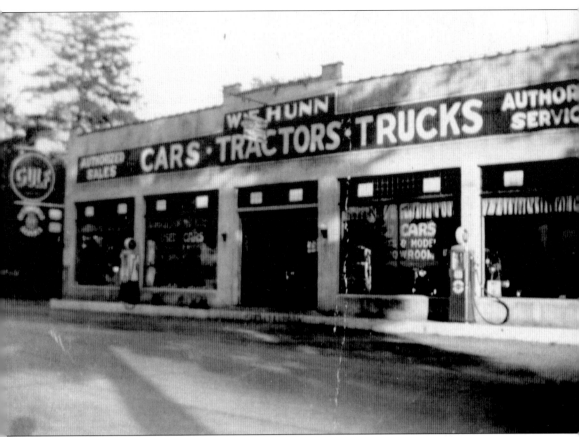

William Hunn opened the first gasoline and service station in Spotswood. Located on Main Street, the garage sold Gulf products to area residents. In this image, the business advertises that it repairs tractors, providing the many farmers in the area with the services of a mechanic. Over the years, this business became an Oldsmobile dealership, after beginning as a Ford dealership. The Giancola family owns the present dealership on the site. The site's continuing use is a rare example of a small-town dealership that did not relocate to a nearby highway site.

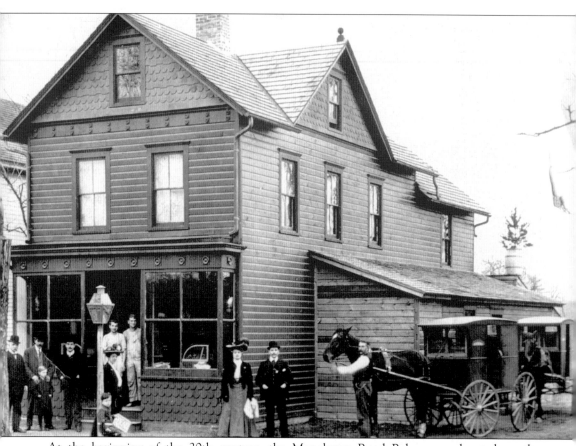

At the beginning of the 20th century, the Manalapan Road Bakery was located on the Bordentown Turnpike (Manalapan Road) at the corner of John Street. Early Spotswood settlers lived primarily along Main Street, which continued onto Helmetta.

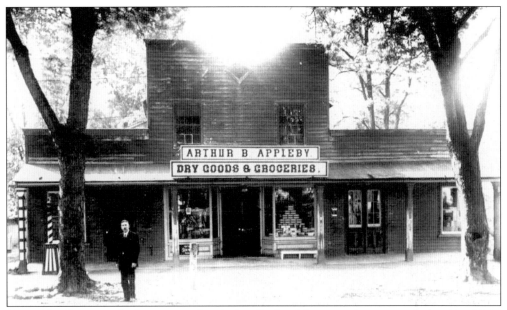

Owned by Spotswood's first mayor, the Arthur B. Appleby general store was located on Main Street where Middlesex Motors now has its used-car display area. For a time, the post office was located there. This photograph was taken *c.* 1920. The structure survived until the 1960s. It housed several enterprises, including a meat market, a shoe-repair business, and (for a brief time in 1960) the local presidential campaign headquarters for candidate Richard Nixon.

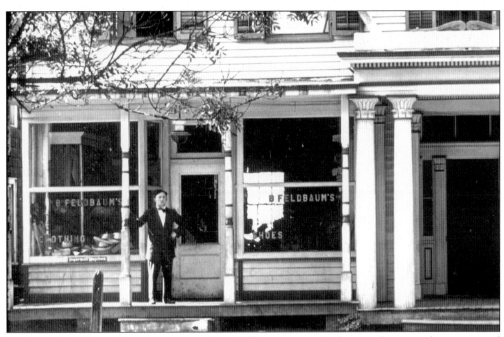

In the early 1920s, this structure at 6 Snowhill Street was the home of a general store owned by the Feldbaum family. The building stood until the 1990s, housing a pharmacy and Kostylanyi's food store, and serving as housing apartments.

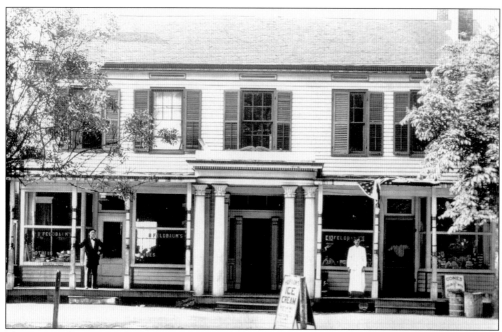

Shown on the left in this picture is the B. Feldbaum clothing store. The soda fountain where you could buy ice cream is visible on the right.

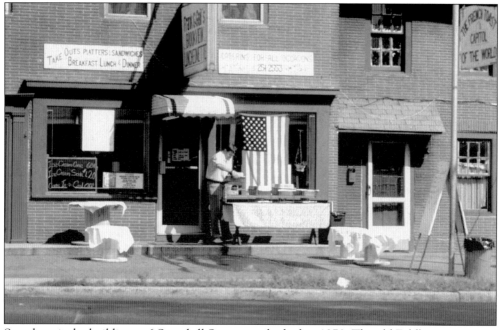

Seen here is the building at 6 Snowhill Street as it looked in 1970. The old Feldbaum store was converted to a diner-style restaurant. It was known at one time as Blanche and Bill's Brookview Diner. When this picture was taken, the establishment was called Frank and Gail's, which advertised itself as "the French Toast Capital of the World." Today it is the Spotswood Diner.

Five
RECREATION

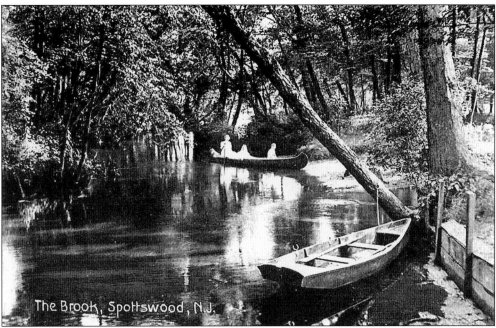

The Brook, Spottswood, N.J.

At the beginning of the 20th century, many families enjoyed boating along the Manalapan Brook. Spotswood was largely known as a summer resort. Most of the houses near the lake were summer cottages with no heat. Many of these houses were built and sold by Elmer Appleby, for whom Elmer Avenue, off DeVoe Avenue, is named.

Better known as the Matchaponix Brook, this was the scene of much boating. Boaters could navigate the brook all the way to the Amboys. The Matchaponix Brook emptied into DeVoe Lake to the west. To the north, DeVoe Lake spilled into an area where the Cedar Brook and the Manalapan Brook combined. This body of water eventually made its way to Duhernal Lake in Old Bridge, before becoming the South River. The name "Duhernal" is derived from the three industrial firms that created the lake: E.I. Dupont de Nemours of Parlin, Hercules Industries of Parlin, and National Lead of Sayreville.

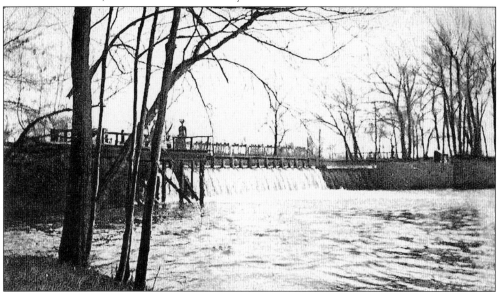

Spotswood developed as a mill town because of the hydropower available at the local dam. The dam created DeVoe Lake by holding up waters of the Manalapan Brook. The original dam had a footbridge span to allow for pedestrian traffic. This image is taken from an early postcard, designed to promote the tourism industry in the borough. The first incarnation of the dam featured a pedestrian walkway to allow visitors to appreciate the beauty of the area.

54

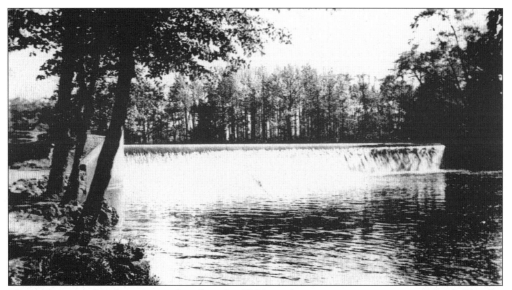

The earlier wooden dam was replaced in the 1930s with a new concrete structure funded by the Work Projects Administration. The dam was improved, as floodgates were added to better control the flooding that occurred during the rainy season. One Spotswood tradition of the mid-20th century was the annual Fourth of July fireworks, which were launched from Snake Island, located in the center of the lake.

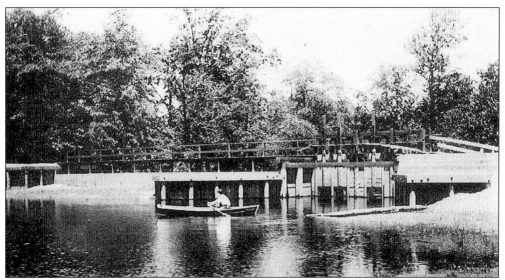

Lake Ruth, renamed Lake Marguerite after Bernarr MacFadden's daughter, was the home of Physical Culture City, on the Monroe-Spotswood border in what was known as the Outcalt section. Physical Culture City was a health resort operated at the beginning of the 20th century by Bernarr MacFadden. The name "Outcalt" comes from the German munitions concern that had planned to build a gunpowder plant at this location.

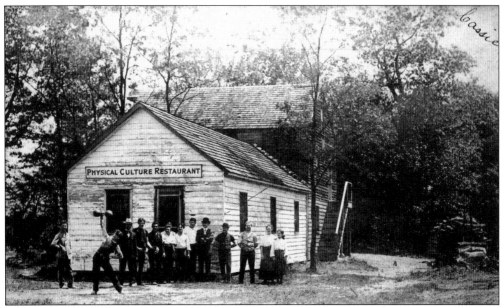

Seen here is the Physical Culture Restaurant. Bernarr MacFadden operated Physical Culture City at the dawn of the 20th century as a health resort. He considered Outcalt the healthiest place around because of the pines in the area and the sulfur in the ground. The present-day Veterans of Foreign Wars building on Daniel Road sits where the restaurant was located. This restaurant served "physical culture stew," which consisted of vegetables, mostly corn, but the health-food establishment also served candy.

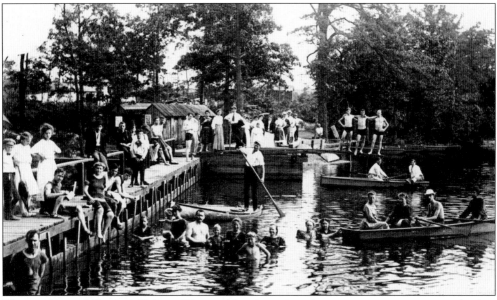

The residents of Physical Culture City could enjoy swimming, water sports, tennis, and other games. Lake Marguerite was originally created for the Hominy Hill Tobacco Mill. It was a beautiful body of water with a stunning waterfall. A yearly tradition on the lake were boat races, held over the then newly declared Labor Day holiday weekend.

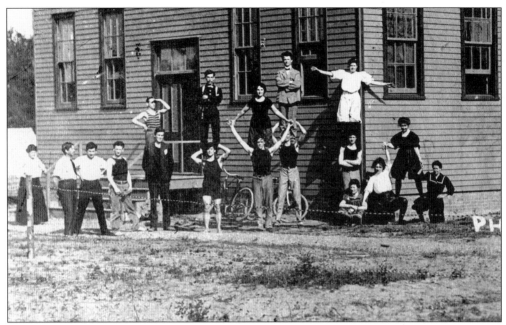

Spotswood attempted to regulate the behavior of the Physical Culture City residents by passing ordinances prohibiting indecent exposure. It was considered scandalous behavior for men to walk the streets attired in only trunks and for women to sport bloomers. The residents were often seen walking barefoot in the early morning. Making contact with the dew on the ground was considered part of the treatment for the residents' various ailments.

Bernarr MacFadden owned and operated the Physical Culture City on the Spotswood-Outcalt border. He printed a magazine, *Physical Culture,* in his plant on the north shore of Lake Marguerite. He was asked to leave town in 1908 after his "scantily clad" patrons offended the prevailing sensibilities of the time. He ran afoul with the law when his magazine was found to be obscene after he sent it through the mail. He was tried and sentenced to two years in prison and fined $2,000. A pardon was recommended shortly after his conviction, and he moved out of Outcalt, never to be seen again.

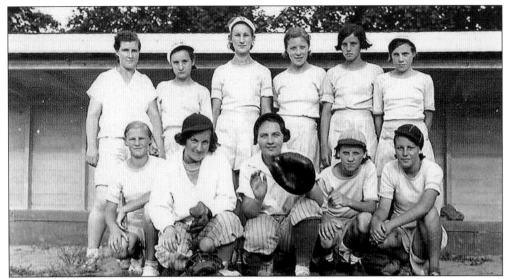

These members of the 1933 Spotswood girls' softball team are, from left to right, as follows: (front row) Lillian Lisiewicz, unidentified, Violet Chitren, Bertha Chriten Soden, and Kathleen ?; (back row) Dora Welsh, Ann Merbler, Florence Lisiewicz, Frances Lerch, Emma Glock, and Una Beebe Makson.

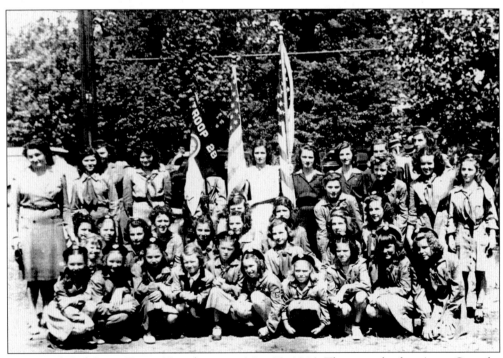

Spotswood Girl Scout Troup 28 is shown on May 30, 1946. The troop leader, Anna Corrado, is standing to the left.

This *c.* 1960 photograph shows Spotswood's Cub Scout Pack 35. This group, one of four to six dens in Pack 35, met weekly after school at the old Hulse Funeral Home, located on Main Street, under the direction of den leader Alice Eckman. The group undertook projects such as birdhouse building and ceramics and put on skits. Shown here, from left to right, are the following den members: (front row) unidentified, unidentified, and Stuart Zagnit; (back row) Bobby Anderson, Jimmy Miller, Chris Strum, and Bruce Eckman. Other den members included Tom DeCandia and Joey High.

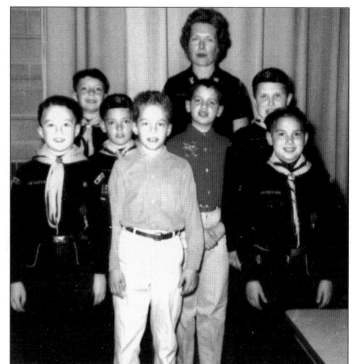

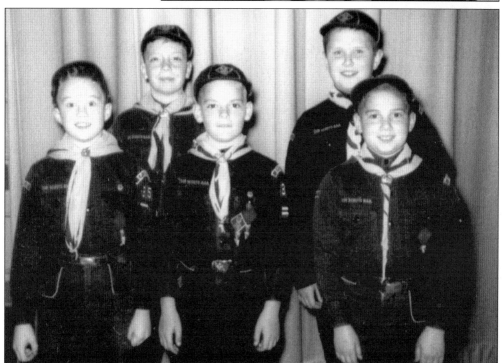

Seen here *c.* 1960 is Cub Scout Pack 35. Scouting was an important asset to the borough. Local scouting first was organized in 1927 by Henry W. Yahnel, who became the first scoutmaster. Both Cub Scouts and Boy Scouts were extremely active in wildlife preservation.

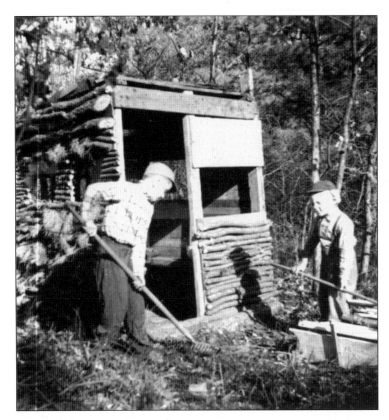

Longtime Spotswood residents Fred Eichenlaub (left) and Jack Eichenlaub are seen building their fort in the woods at the end of Jackson Street. Many local children used this area near Ducky's Pond for recreation. The area is now a part of the northwest corner of the Spotswood High School property, near the football stadium.

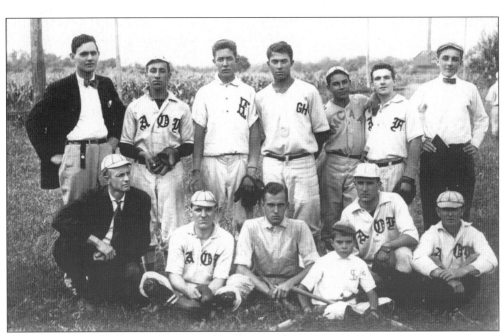

A local men's baseball team is seen in this photograph.

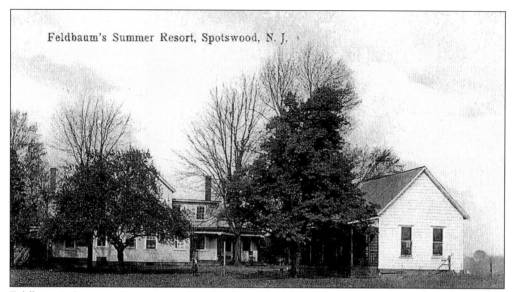

Feldbaum's Summer Resort, Spotswood, N. J.

Feldbaum's Summer Resort was a boardinghouse type of vacation spot. It stood on the present site of the Spotswood High School. Comprising 300 acres, the resort included the small homes still standing on Feldbaum Place. Built in the early 1900s, the resort catered to Jewish vacationers, making it, according to the late David Feldbaum, whose grandfather owned it, "ahead of the Catskills." There was a duck pond in the back that was used by local youths for skinny-dipping. The main building, seen in this picture, was later the Wisotski farmhouse. It was razed to make way for the high-school complex.

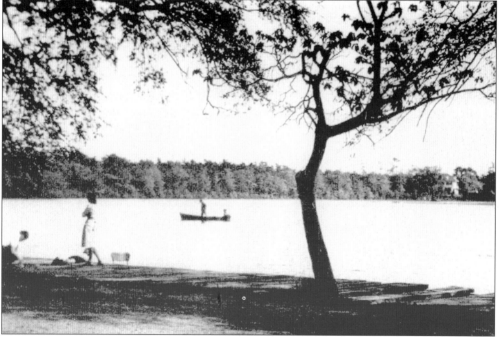

Spotswood Lake was once the source of recreation for visiting summer residents. The lake provided boating, fishing, and swimming. It was improved as a federal Work Projects Administration initiative in the 1930s, when a major dredging was undertaken.

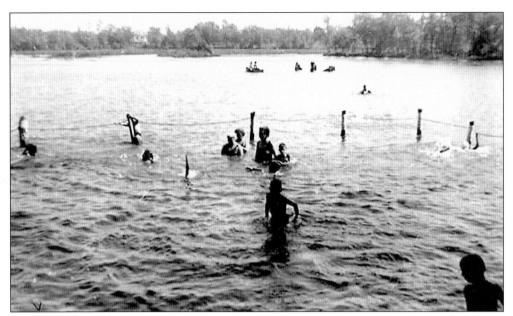

Spotswood Lake was originally formed when the Native Americans who first settled in this area built a dam. The site of the original dam was located at the mouth of the Matchaponix and Manalapan Brooks. *Matchaponix* means "poor land not producing anything out of which good bread can be made." *Manalapan* means "a good country producing good bread."

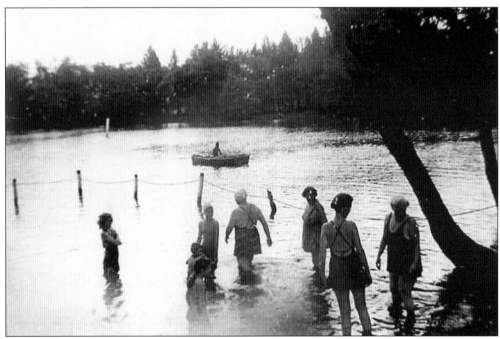

In this photograph, it is evident that many of the borough's residents enjoyed swimming at Spotswood Lake during the hot summer months, as did the early settlers of Spotswood who enthusiastically described the lake as "sweet, wholesome and delightful."

Six

UNIFORMED SERVICES

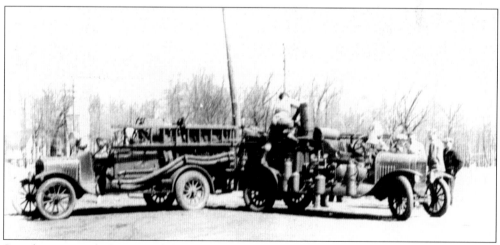

Seen here are early Spotswood fire trucks. The local fire department was founded on May 10, 1898, as the Enterprise Hook and Ladder Company. Thirty-two men were unanimously elected members. The original officers included David Outcalt, president; John M. DeVoe, vice president; Elwood M. Skinner, secretary; and Fred H. Cornell, financial secretary. Shown here is the Model T truck purchased in 1925.

Early Spotswood firemen are seen in this photograph. Willard C. "Shorty" Applegate was owner of the general store located next to the what is now Art's Auto Body on Snowhill Street. He supplied his customers with chickens purchased from local farmers. Here he poses in front of the new 1936 Diamond T 500-gallon pumper. The fire department purchased this truck after a municipal water system was installed in 1935.

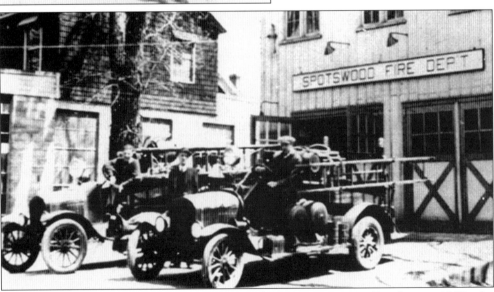

This is an early-1900s view of the Spotswood Fire Department. By August 1898, the department membership was up to 68 men. On the night of October 31, 1898, the men responded to their first fire alarm. Fire had broken out in a building located near the Little Pond, owned by George Appleby. The fire was extinguished using the first piece of apparatus purchased, obtained from a Long Branch company at a cost of $56.

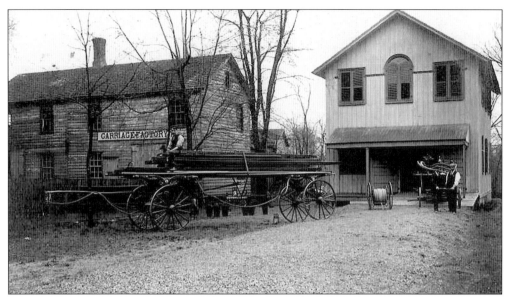

The Spotswood firehouse and carriage house was located on Main Street. Carriages were made at this site, behind the present-day Oldsmobile parking lot. The firehouse was originally located behind the present-day Jackson-Hewitt Tax Service on property owned by A.A. DeVoe in back of Underhill's and Cornell's stores. The cost of this building was $130. In 1905, the fire department purchased the old schoolhouse (pictured here) on Main Street for a sum of $800.

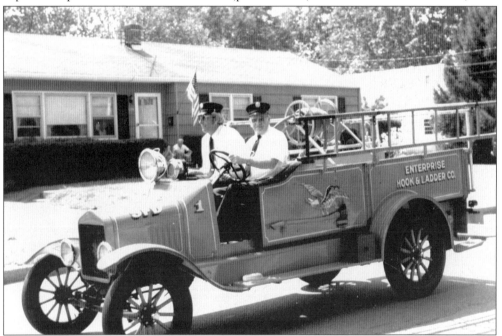

In October 1925, the Spotswood Fire Department received a Model T chemical truck from the Formedi Child Company on a 30-day trial basis. The truck proved satisfactory and was purchased for $1,975. In conjunction with this truck purchase, the borough and the department constructed a series of pumping stations on the lake and borough streams in order to make provisions to fight fires throughout the borough.

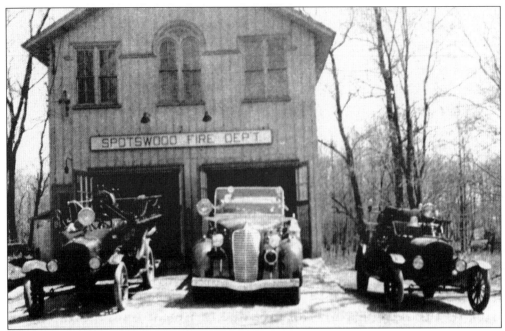

Seen here *c.* 1940 is the Spotswood Fire Department. On November 14, 1938, 13 of the wives of local firemen met with two representatives of the South River Fire Department Ladies Auxiliary. These women, plus one other wife, joined together as charter members of the Spotswood Fire Department Ladies Auxiliary. The first officers were Mrs. Kenneth Hodapp, president; Mrs. Louis Dinkel, vice president; Mrs. John Larkin, secretary; and Mrs. Elmer Appleby, treasurer.

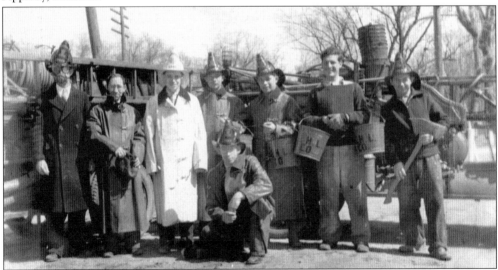

This is a view of the Spotswood Fire Department in the 1930s. Fire alarm call boxes were installed within the borough in 1929 in order to provide a more effective way of reporting fires. When a municipal water system was installed in 1925, it was possible to install fire hydrants and mains throughout the borough, eliminating the need for pumping stations in the local waterways. Note the buckets, undoubtedly left over from the pump station days, that are held here by several members.

The white structure shown here on the right was the first home of the Spotswood Fire Department, which was organized in 1898. The first chief was David Outcalt, and other members had last names such as Appleby and Vliet.

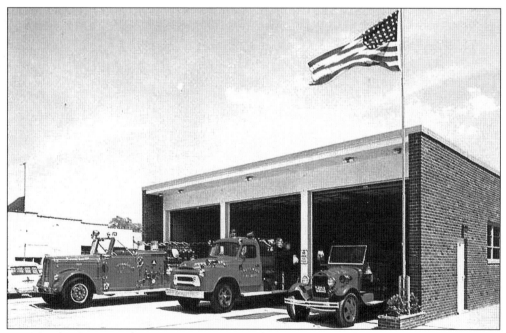

In 1960, the Spotswood Fire Department moved into its current brick home on Main Street. The Model T truck on the right is still running and appears in parades and other activities. The truck on the left was partially paid for with civil-defense funds. It was in service for 30 years before being replaced with more modern equipment. This brick structure was the first firehouse in town whose doors actually locked.

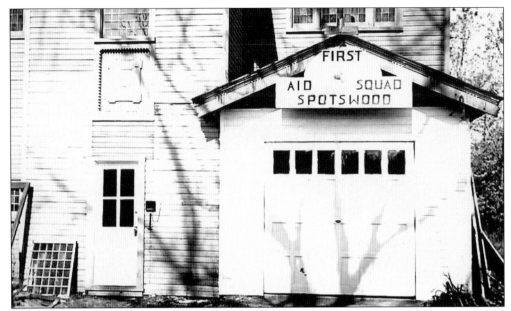

This is the old building of the Spotswood First Aid Squad. The Spotswood First Aid Squad was organized in 1941 with the assistance of the Spotswood Fire Department. The first squad building was located behind the old community house where the library parking lot is now.

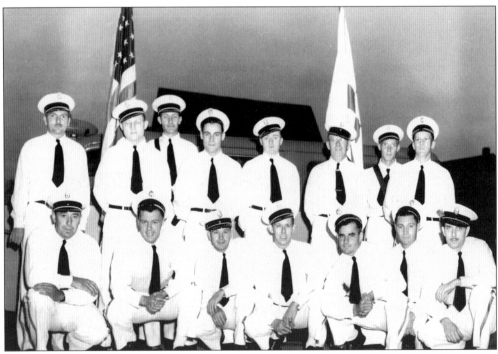

Members of the Spotswood First Aid Squad pose in 1950. From left to right are the following: (front row) "Hap" Brown, Robert Schellenberger, Jerry Lins, unidentified, and George Logan; (back row) Fred Linke, Bernie Cerebe, Harvey Cottrell, Ed Schellenberger, unidentified, unidentified, Kenny Schellenberger, and unidentified.

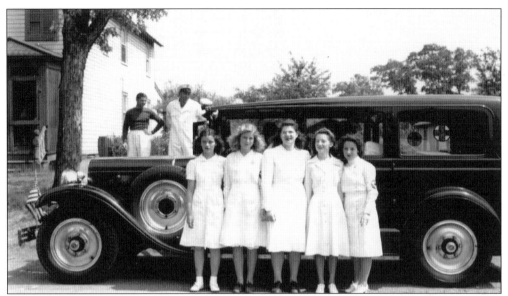

This May 1942 photograph shows the Spotswood First Aid Squad's "rig." It was a converted hearse that was purchased to function as an ambulance. The floorboards were rotted out on the bottom, and when it was driven through puddles of water, mud would splash up through the floor. Most of the men in the community were serving in the military at this time, so only women were available to serve as active members in the first-aid squad. As the picture shows, the women wore nurses' uniforms when they went out on calls. Pictured, from left to right, are Shirley Glock, Ruth Ide, Gladys Shapiro, Doris Magee, and Eleanore Magee. In the background is Lester "Hap" Brown.

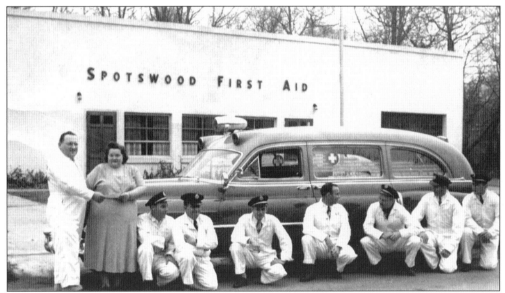

These members of the Spotswood First Aid Squad are, from left to right, Alvin Zagnit, Hazel Linke, Edward Schellenberger, Bob Calandrilla, Jerry Lins, Edward Nelson, Fred Linke, unidentified, and Bernard Cerebe. This rig was a newly purchased Cadillac ambulance. It replaced the converted hearse formerly used for this purpose.

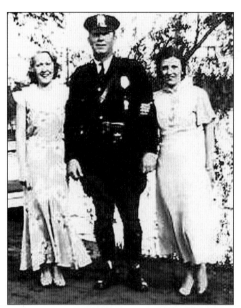

Charles Sengstack was appointed as the borough's first full-time police officer. He patrolled mostly by walking a Main Street beat. One of Sengstack's police belt accessories was a hammer. He was known to help citizens along his beat with various repairs to fences, pens, and buildings.

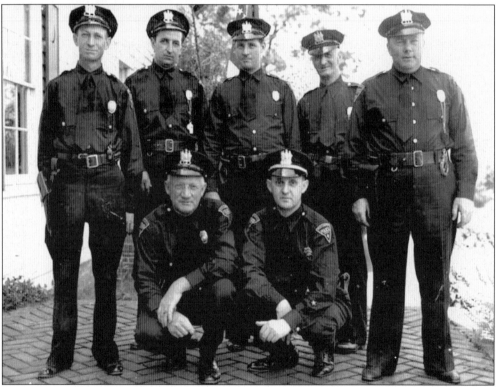

This is a 1940s photograph of the Spotswood Police Department. From left to right are the following: (front row) Joseph Beebe Sr. and William Goldsmith (chief); (back row) Charles Seevers, Woody Witlock, Joseph Beebe Jr., William Riley (truant officer), and Ellwood "Doc" Dougherty. Chief Goldsmith was the only full-time paid police officer in the borough. The other officers who made up the seven-member police department were specially appointed and worked only part-time.

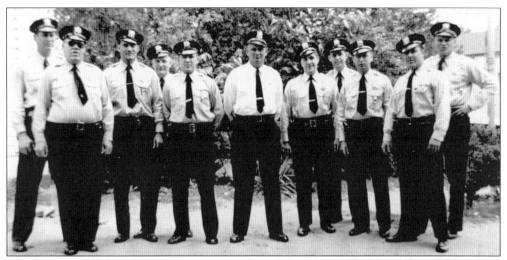

The Spotswood Police Department is pictured in 1958. The members are, from left to right, Fred Sharp (1955–1961), Phillip Hoffman (1954–1960), Harry R. Geipel (1954–1961), David Wycoff (1952–1955), Eugene Scheicher (1955–1967), Chief Vincent O. Woodmansee (1950–1965), William Steindecker (1956–1986), Robert Nash (1953–1957), Edward Colhoun (1952–1962), George Ahrend (1955–1986), and Stephen Bialck (1953–1961).

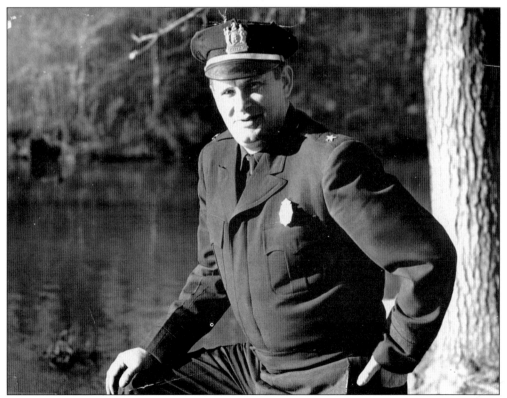

Vincent O. Woodmansee was chief of police from 1951 until his untimely death in 1965. The chief was the only full-time paid police officer within the department of 12 officers. Woodmansee rose to national prominence with his establishment of Spotswood's bicycle-safety program.

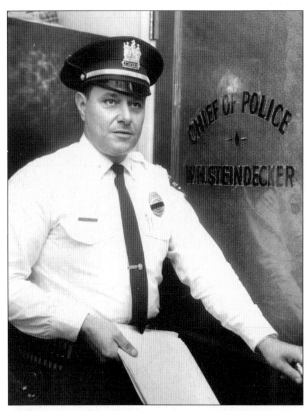

William Steindecker served the borough as police chief from 1965 until his retirement in 1986. Steindecker was appointed to replace Vincent O. Woodmansee after Woodmansee's untimely death. Steindecker is seen here at his office door in the community house. He described his office as being no bigger than a closet.

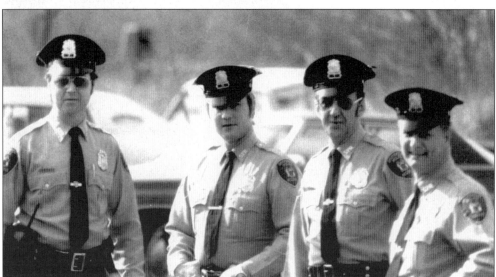

Pictured here are some of the members of the Spotswood Auxiliary Civil Defense Police, citizens who volunteered their time to assist the borough's full-time paid police. These men and women were part of our nation's civil defense and preformed duties such as ride-along on patrol, crowd control, security for school events, and other various assignments deemed necessary by the chief of police. In this group are, from left to right, Richard Cia, Henry Brooks, Edward Lapham, and William Pollack.

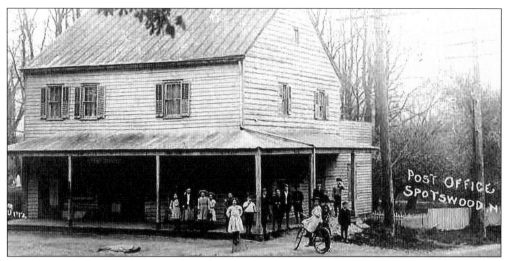

The original site of the borough post office was the corner of Main Street and DeVoe Avenue. The property is now part of St. Peter's Episcopal Church graveyard. The space above the post office was a clubroom for the Fishermen, a boys' club organized by Rev. Robert Bell, priest of St. Peter's.

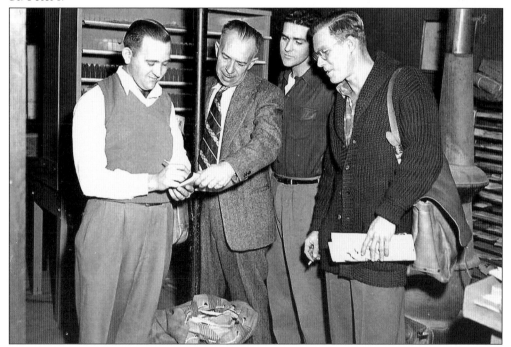

The first letter carriers in Spotswood are seen in this February 1952 photograph. They are, from left to right, Harvey Uhl, John "Jack" P. Larkin (postmaster), Harold "Murph" L. Snure, and Kenneth Schellenberger. Direct mail delivery to homes and business in Spotswood began in 1952. Prior to this time, mail had to be picked up in the post office building on Main Street. The letter carriers pictured here were required to excel at a civil service exam given in New Brunswick. Harvey Uhl became Spotswood's postmaster when Jack Larkin retired. Murph Snure became director of public works for the borough of Spotswood. These gentlemen all served the borough in various volunteer organizations.

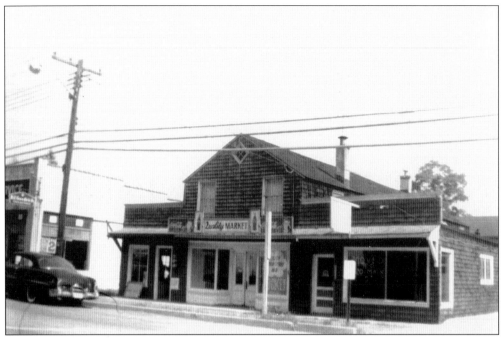

Between 1930 and 1940, the Spotswood post office was located in the right-hand side of the building shown here. It sat next to the firehouse. The site is now owned by Giancola Used Cars. The postmasters during this time were Tillie Hodapp (1922–1934) and Mary Appleby (1934–1943). From this early time, women in Spotswood served in leading management roles.

U. S. POST OFFICE, SPOTSWOOD, NEW JERSEY

After the Appleby general store went out of business, the post office moved to its third home, a brick building that sat where the present-day Exxon station parking lot and the entrance to the Rite Aid and Cambridge Inn are located. At various times, Certo's Pizza restaurant shared the building, as did Harke's Middlesex Electrical Supply and Stryker's Auto Parts.

Seven
OLD-TIME HOMES AND FAMILIES

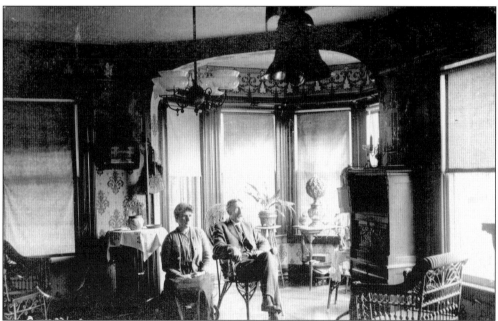

Mayor Arthur B. Appleby sits with his wife at their home on Main Street. Appleby owned and operated a general store directly across from his residence. The Applebys had owned land in this area since the early 1800s and were among the wealthiest families in the area. At the time this photograph was taken, electricity was not yet available to most homes. Note the oil lamp in the background and the gas lamp in the ceiling.

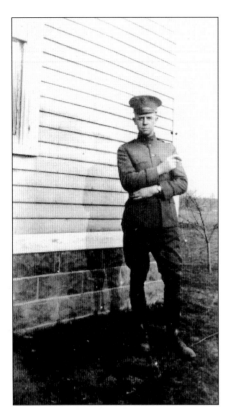

Seen here in his World War I uniform, Herman R. Lettau lived on South Street. He was a member of the Spotswood borough council. American Legion Post 253 was named after him. Two streets, Lettau Drive and Herman Drive, are named after him as well. Barbara (Lettau) Rasmussen and Ada (Lettau) Schellenberger, his descendants, still live in Spotswood on Herman Drive.

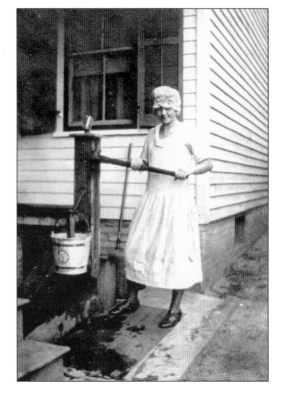

Dorothy (Kramer) Applegate, a lifelong resident of Spotswood, owned Applegate Florist on Main Street for many years. The Applegates are longtime residents of the area and grew their own flowers on Brunswick Avenue. Dorothy Appelgate's son John Applegate started the florist business in 1939. The business was located in the front portion of their residence at 456 Main Street. This building continues to operate as a florist business, the Flower Zone, today.

Gloria (Sengstack) Uhl models her new Sunday best in the center of Mundy Avenue in the 1920s. This view looks east toward Old Bridge. Mundy Avenue is named after Phineas Mundy, who was a prominent businessman in the area. He owned land and the Old Red Mill, which made paper. Mundy Avenue was a dirt road at the time of this view. Oil was once spread on main area roadways to keep the dust down.

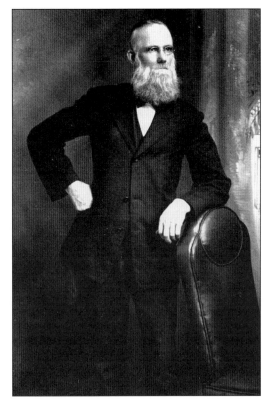

A carpenter by trade, Charles E. Campbell lived on John Street in the 19th century. He cared for the Reformed Church cemetery and was the grandfather of future postmaster Harvey Uhl and Tressa (Uhl) Bauman, who continue to live on John Street here in the borough.

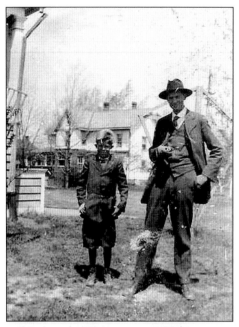

Brothers Irving A. Lettau (left) and William L. Lettau are pictured in 1920. The younger brother, Irving, later became a builder of several area housing developments and constructed Cape Cod–style houses west of Summerhill Road. Irving Avenue is named after him. His partner, Herbert Lauffenberg, memorialized their partnership in the street named Ellenel Boulevard, after their initials, "L and L." William Lettau was a borough recorder who went on to serve as the magistrate from 1930 to 1963.

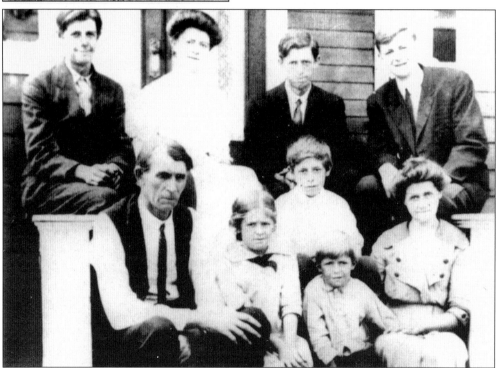

William Lettau (1861–1918) and his wife, Amanda Lettau (1863–1937), are seen in this 1938 photograph with their children at their lakeside homestead. From left to right are the following: (front row) William Lettau, Elsie Lettau, Walter Lettau, Irving Lettau, and Amanda Lettau; (back row) Herman R. Lettau, Helen Lettau, Arthur Lettau, and William Lettau. William Lettau was an architect in Minnesota. He then became a builder when he moved east. Amanda Lettau is mentioned in *The Pioneer History of America* (1884), by Augustus Lynch Mason.

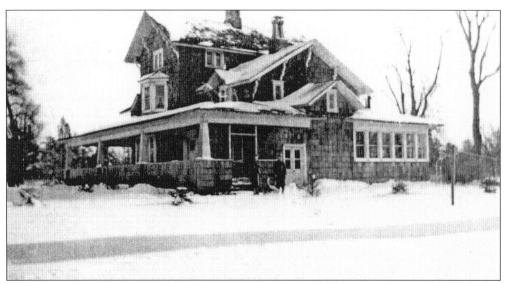

This is a 1938 view of the Lettau family home, located on Lakeview Drive. The windmill on the property can be seen clearly from the lake. It was used to pump running water into the house in the early 1800s. In its time, this house was one of the largest homes in Spotswood.

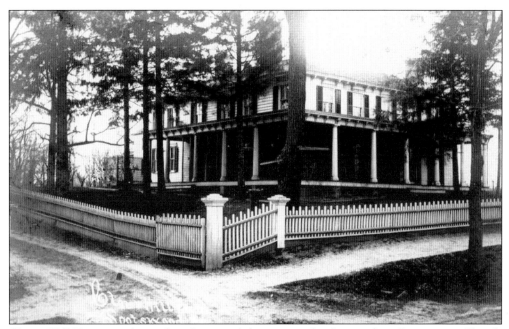

Clover Hill Farms was located at the site of the present-day Immaculate Conception Church on Manalapan Road. The Hazlehurst family owned this estate. Today, the occupants are the Felecian Sisters, who serve as teachers in the Immaculate Conception school. The Clover Estates housing development is named after Clover Hill Farm.

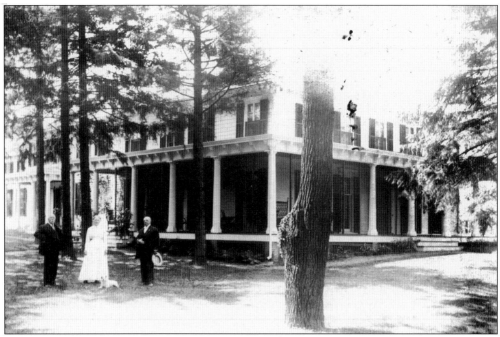

The Hazelhurst family, pictured here on their estate, Clover Hill Farms, was one of the wealthiest in the borough. The family employed one of the first female African American residents of Spotswood as a maid. She was frequently seen shopping along Main Street, as Mrs. Hazelhurst remained homebound.

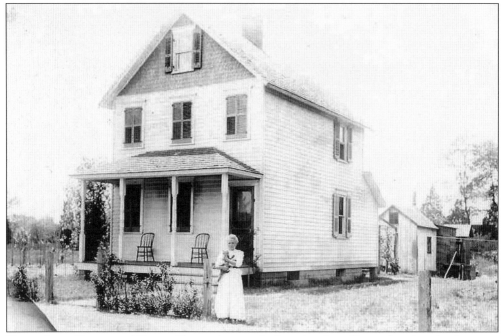

Shown here, Gustov and Tressa Gager, along with their daughter Tressa, lived in this house at 24 John Street. Tressa Gager is holding a cat. In 1947, the Gagers sold their home to Frank and Mary Labonak. Mary Labonak and her son Kenneth Labonak still live there today.

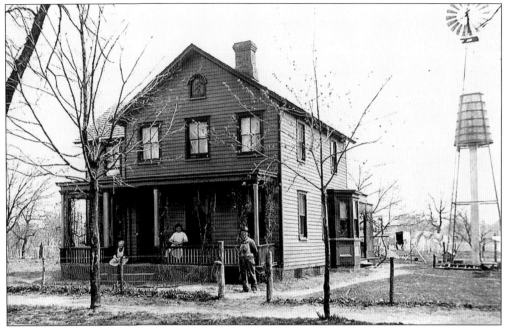

Seen here is the Vliet home. When Spotswood became a borough, it was a placid little community, ranging for the most part along Main Street, which was lined with tall, old trees. Comfortable wood-frame houses were built on spacious grounds.

The Vliet garden is seen in this early photograph. At the beginning of the 20th century, almost everyone in the Spotswood section of East Brunswick had a vegetable garden and kept a few chickens, a horse, and even a few pigs. Central New Jersey developed as an agriculturally based economy. What you did not grow on your own you could buy at three local general stores, owned by Arthur B. Appleby and Dill, Fred Cornell, and Edward D. Underhill.

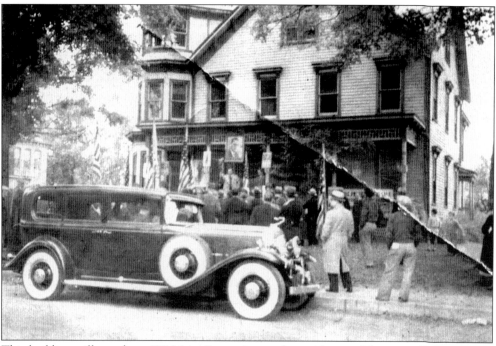

Russell F. Kane, who served as the mayor of Spotswood during the late 1950s and into the 1960s, was active in the Lions Club. He also served as the manager of the First National Bank of Spotswood. The New Jersey Conference of Mayors sponsored the billboard shown here to promote the economic development of the borough. The sign was located in the east end of Main Street. Motorists could see the sign when they traveled west from East Brunswick, just past Cleveland Avenue. The Economic Development Commission carries on this promotion today.

This building still stands at 490 Main Street. It was the residence of Spotswood's first mayor, Arthur B. Appleby, who also owned and operated a general store directly across the street. It is supposed that this picture depicts a political whistle stop on a tour by Morgan F. Larson, governor at the time. The automobile in the picture is a 1930 Packard town car. The building later became the home of Dr. Ulan and his medical office. A general practitioner, Ulan served as the Spotswood school physician for many years.

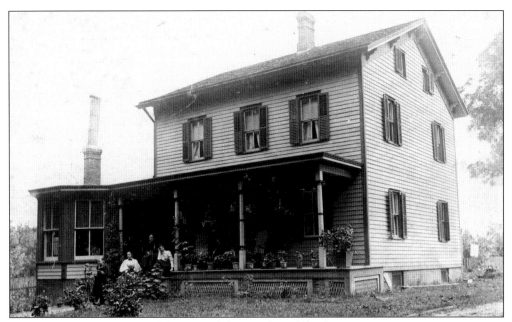

Spotswood's first mayor, Arthur B. Appleby, purchased this house at 490 Main Street.

The Arthur B. Appleby family poses for a picture. Note the two family horses. Many families living along Main Street at the time typically owned a variety of animals and livestock. Anna Olivia Appleby, daughter of Arthur B. Appleby, married William Lettau, who served as Spotswood's magistrate for many years.

The Soul Culture Institute of Old Bridge was located at 24 Main Street. This house stills stands today. When Spotswood and East Brunswick were divided, between 1840 and 1852, it became part of Spotswood. Today residents refer to it as "the big yellow house." The Clyne family, which grew eggplants as a crop, originally owned this house. The property extended from Main Street to Old Stage Road. The surrounding streets are named after the Clyne family members: Sidney, Victoria, and Dora.

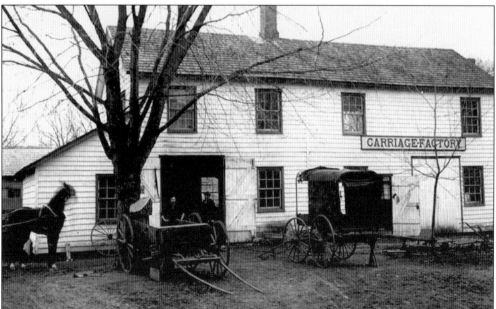

The carriage factory building was located on Main Street next to the old firehouse building. The property is now located to the rear of the Giancola used car lot. Part of this building still stands and is used by the Giancola dealership. The carriage factory manufactured the prime mode of transportation during the 1800s. Spotswood was considered a hub for the surrounding farming communities. Farmers brought their plows and wagons here to be repaired.

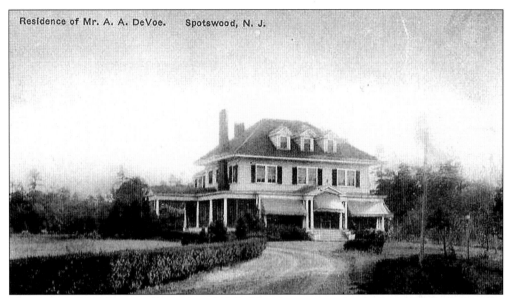

Residence of Mr. A. A. DeVoe. Spotswood, N. J.

The A.A. DeVoe house still stands at 222 DeVoe Avenue on the shores of DeVoe Lake. The DeVoes owned and operated several mills in Spotswood as early as the 18th century. For many years, Steven and Dorothy Patron owned this home. Today this area is populated by many lakefront homes, but during the pre–World War II era, there were only three houses located on the lake. The other two were the Lettau and Hazlehurst homes.

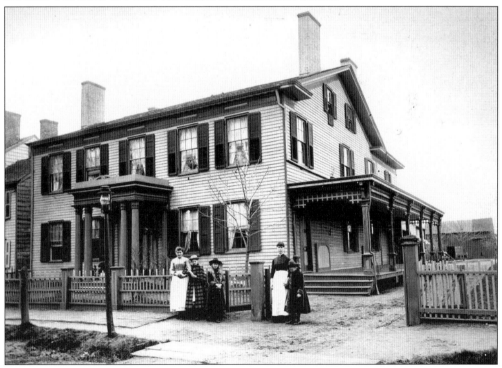

Dated 1886, this photograph portrays the Welsh family. The building shown here later became the Spotswood Community House and library. Ada Schellenberger of Herman Drive, a descendant of the Welsh family, provided this picture.

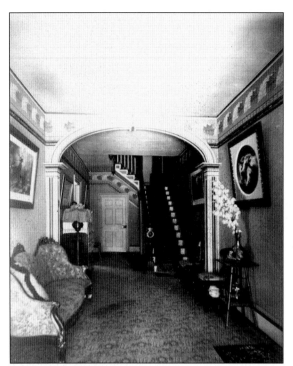

This view shows the main entrance into the vestibule of the Welsh family home. Florence Welsh was tutored at home here. The Welsh family was related to two of the other prominent families of the area, the Applebys and the Helmes, who ran the snuff mill in Helmetta.

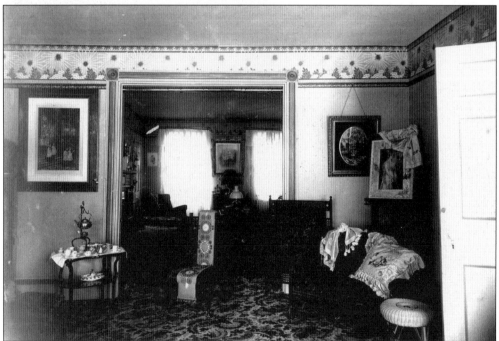

This ground-floor room of the Welsh house was often referred to as the sitting room. The Welsh family left their home to the borough of Spotswood. The Appleby de Sille Foundation managed it, along with the large empty lot across the street. This lot came with a restrictive covenant; the borough could not build any type of structure on this land. Today the land serves as the borough parking lot.

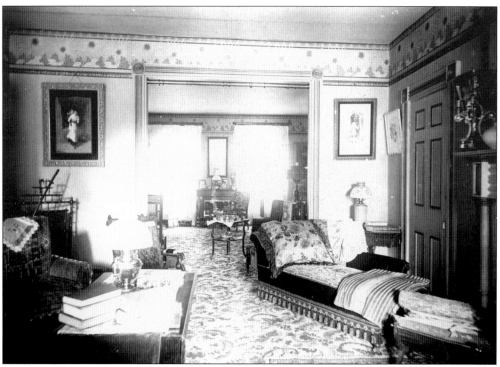

This view shows the Welsh home's ground-floor parlor.

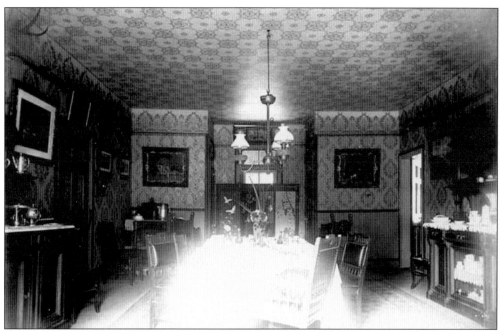

Seen here is the formal dining room of the Welsh home.

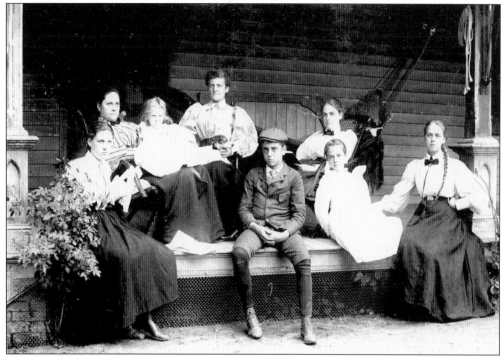

The Welsh family sits on their back porch for this photograph.

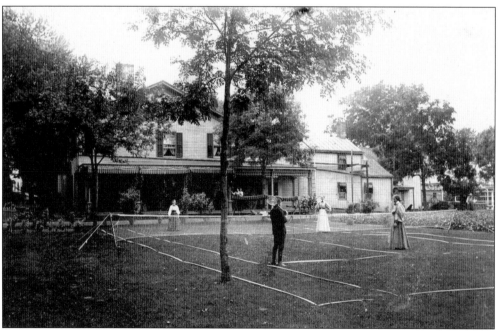

A grass tennis court was located in the backyard of the Welsh residence.

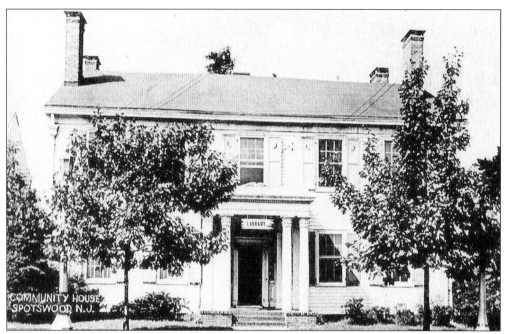

From 1920, this building was a community house maintained by the Appleby de Sille Foundation. In 1927, the community house also became the home of the borough's library after the receipt of a $5,000 donation from Fred DeVoe for this purpose. The Spotswood library now bears the DeVoe name.

From the 1920s until *c.* 1970, the public library was housed in what was known as the Spotswood Community House. This property was conveyed to the borough by the Appleby de Sille Foundation, which purchased the 1783 house with the goal of establishing a library. For a time, the library shared the premises with the municipal government and police department. In 1969, the library was forced to vacate the historic property when it was found that the building was structurally unsound. In December 1973, the present 4,000-square-foot library, a prefabricated construction built upon the site of the old community house, was dedicated.

The community house is shown as it looked in the early 1940s. The mayors of Spotswood used this building as their office. Those who served terms as mayor have included Arthur Appleby (1908–1914), Phineas Bowne (1915–1916), J. Randolph Appleby I (1917–1918), Peter Schweikert (1919–1920), Charles DeVoe (1921–1922), Augustus DeVoe (1923–1924), E. Raymond Appleby (1925–1926), Nelson Jolly (1927–1930), and George Siegel (1931–1958).

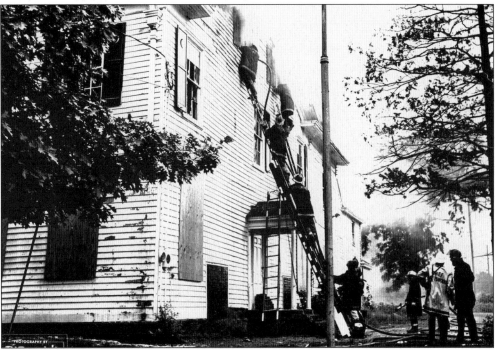

On July 26, 1971, the community house was destroyed by fire. The building was vacant at the time because it had been declared unsafe due to structural problems.

Eight
GOVERNMENT

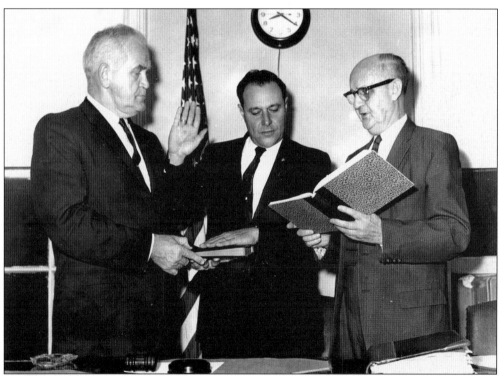

Mayor Russell Kane (left) and longtime borough clerk William Goldsmith (right) swear in new police chief William Steindecker in 1965 after the death of former chief Vincent Woodmansee. Kane was the president of the Spotswood branch of the First National Bank of South River and president of the Spotswood Lions Club. The Lions encouraged local youths to become active in borough government activities.

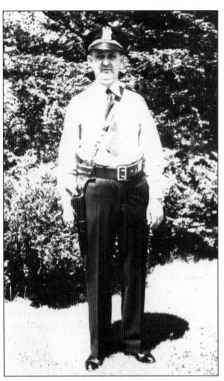

William Goldsmith came into prominence when he was appointed a full-time police chief in 1939. The only full-time paid police officer for the borough, he headed a seven-member, part-time paid police department. Upon Goldsmith's retirement in 1950, he was appointed to the position of borough clerk, in which he remained for many years. Goldsmith is honored with a plaque at the southwest corner of the triangle between Snowhill Street and Manalapan Road.

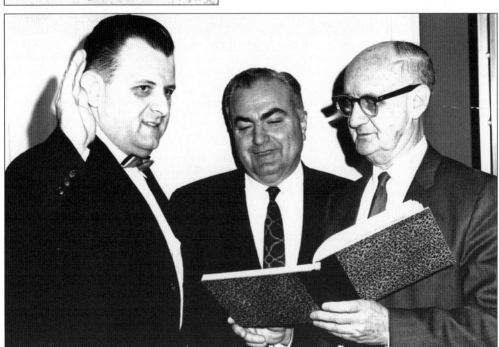

In this undated photograph are, from left to right, unidentified, Patrick DeStefano, and William Goldsmith. Goldsmith continued to serve as borough clerk until 1971, when Mrs. Reggie Pasterczyk replaced him. Patricia DeStefano, daughter-in-law of Patrick DeStefano, is currently serving as the borough clerk of Spotswood (2003).

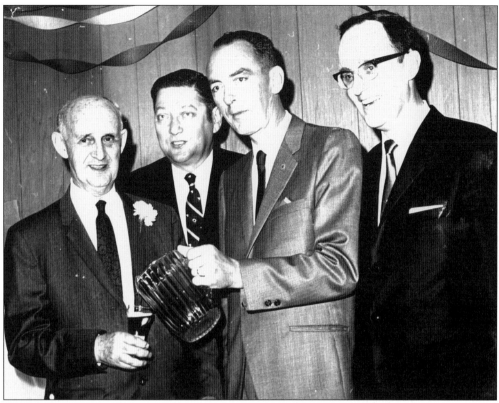

The borough says goodbye to William "Goldy" Goldsmith in this 1971 photograph. From left to right are William Goldsmith, Nathan DuBester, unidentified, and Donald Brundage. Dubester and Brundage both served as commissioners in Spotswood's old form of government. The citizens elected three commissioners, who then chose one of their ranks to serve as mayor. Each commissioner was responsible for certain government departments, such as roads or public safety.

The Appleby ballot represented the referendum to separate Spotswood from East Brunswick and create the borough of Spotswood. On February 26, 1908, a meeting was held in Spotswood (which had been a part of East Brunswick Township since 1860) to consider incorporating the town into a borough. In April of that year, the population of fewer than 800 voted, and Spotswood became a borough in the county of Middlesex.

Citizen's Ticket

Borough of Spotswood, N. J.

JUNE 2, 1908

For Mayor
ARTHUR B. APPLEBY

For Assessor
THOMAS J. BROWN

For Collector
JOHN H. DILL

For Councilmen
AUGUSTINE CORNELL
HAMILTON HAZELHURST
AL. . DeVOE
T. . . . IS PERRINE
WI. . AM J. BISSETT
JOSE. HODAPP, JR.

For Against

An Act, entitled, An Act to incorporate the Borough of Spotswood, in the County of Middlesex.

Approved April 16th, 1908.

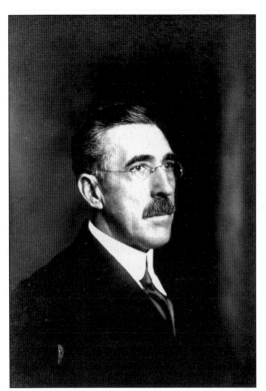

The first mayor of Spotswood, Arthur B. Appleby, took office on June 8, 1908. "The New Jersey State Legislature approved, on April 16th, 1908, that the borough of Spotswood be incorporated. The citizens of this community, by almost unanimous vote, approved said act at an election held on May 12, 1908, in the borough of Spotswood." These words were spoken by Appleby at his inaugural address to the citizens of the new borough.

Governor Hoffman makes a campaign stop in Spotswood at 490 Main Street in 1935. On the right is George Siegel, mayor of Spotswood. This gathering was held at the home of former mayor Arthur Appleby.

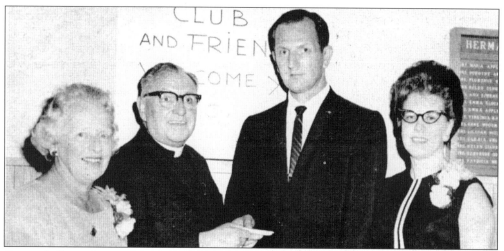

Canon J. Perry Cox and his wife, Mildred Cox, were given a welcome home dinner by the Spotswood area Square Club on September 21, 1966, following the St. Peter's Episcopal Church rector's return home from a 10-week goodwill tour of Europe and North Africa. Shown at the right are toastmaster Joseph Zapora and Mrs. Joseph Zapora. Some 150 well-wishers attended, including Cox's two daughters, Rev. Joseph Woods of the Reformed Church, and Rev. Daniel Martinez of the Methodist Church. Cox, a charter member of the Square Club, was presented a life membership by its president Joseph Zapora, past president Robert Bolch, and vice president William Tonnelly.

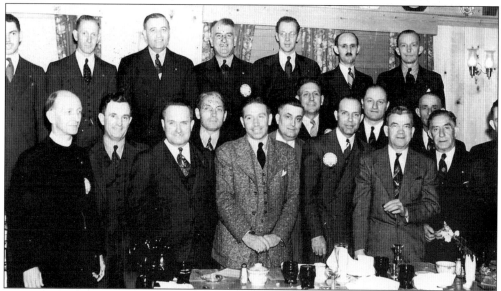

This was the Spotswood Lions Club in the 1940s. From left to right are the following: (front row) Rev. W. Morgan (St. Peter's Episcopal Church), Mayor George Seigel, E. Raymond "Pete" Appleby (board of education member), unidentified, William Hunn (owner of the Oldsmobile dealership), Anthony DeStefano (real estate business owner), Walter Burgess (Spotswood Hotel owner), and six unidentified men; (back row) Kenneth Hodapp (Hodapp's Electrical Center owner), Earl Sparks (inspector for the New Jersey Division of Motor Vehicles), William McMulkin (insurance business owner), unidentified, J. Randolph "Bud" Appleby III (attorney), William Goldsmith (chief of police), and Henry Jensen Sr. (director of public works).

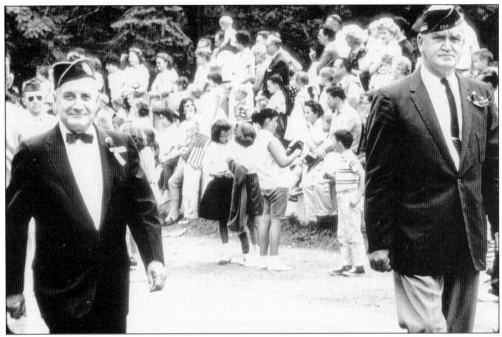

Shown during the Memorial Day parade in 1958 are commissioners Raymond "Pete" Appleby (left) and Russell F. Kane. The Appleby School was named after Appleby for his long, faithful service to the board of education. Kane Avenue was named after Kane, who also served as mayor, and Appleby Avenue was named after Commissioner Appleby. The board of education members in 1958 included Thomas McLaughlin, Charles Sengstack, William Eckman, and Bertram Prolow, in addition to Appleby.

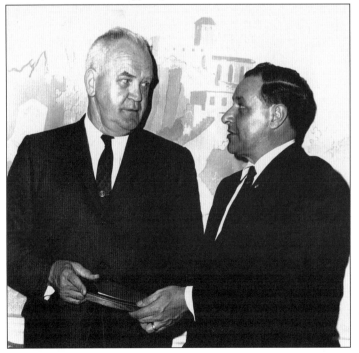

Mayor Russell Kane (left) gives Police Chief William Steindecker an award. The police chiefs of Spotswood have included William Goldsmith, Vincent Woodmansee, and Bill Steindecker. Chief Woodmansee brought the borough to national prominence with his bicycle safety program.

Nine
TRANSPORTATION

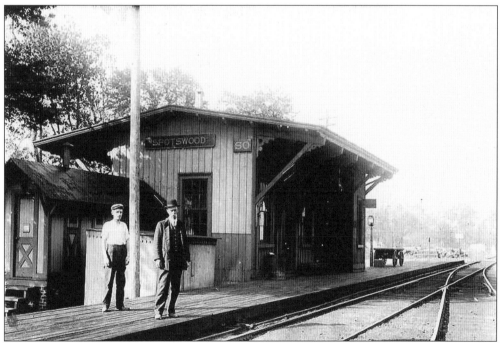

The first railroad in the state, the Camden and Amboy, ran through Spotswood. The first cars were drawn by two horses, which were replaced by a steam engine in 1833. Looking to the west toward Snowhill Street, this view shows the Pennsylvania Railroad station platform. Standing on the platform is a young boy identified as Joseph Beebe. The station was located on the property that is now occupied by Jersey Pride.

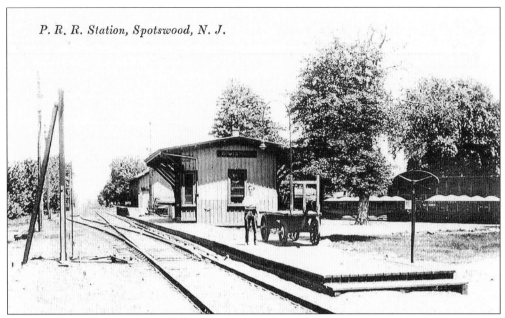

P. R. R. Station, Spotswood, N. J.

Seen here at the railroad station loading dock is a young man standing next to a cart used to unload cargo. The freight and passenger station in Spotswood was located near the center of town close to hotels, merchants, and manufacturing sites. The railroad station was built by the Snowhills and completed soon after the construction of the railway through Spotswood. It was maintained by William Snowhill and was later kept up by his widow.

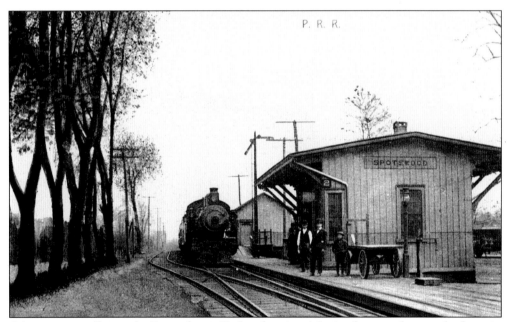

P. R. R.

A locomotive pulls into the Pennsylvania Railroad station. Moving from north to south, the train is headed toward Camden. Today, CNX runs two freight trains through town each day, often awakening the local residents with the sound of their 4:00 a.m. whistles. The station was removed in the 1960s. Periodically, locals talk of reviving a passenger service within the borough.

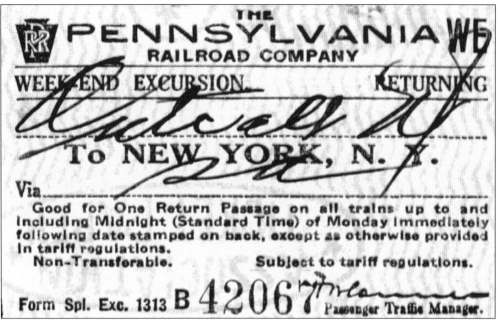

THE PENNSYLVANIA W.E.
RAILROAD COMPANY

WEEK-END EXCURSION. RETURNING

Outcalt N.J.

To NEW YORK, N. Y.

Via _____

Good for One Return Passage on all trains up to and
including Midnight (Standard Time) of Monday immediately
following date stamped on back, except as otherwise provided
in tariff regulations.

Non-Transferable. Subject to tariff regulations.

Form Spl. Exc. 1313 B 42067 Passenger Traffic Manager.

Pictured here is a typical passenger train ticket of the type that took passengers from Outcalt to New York. It reads, "Good for One Return Passage on all trains up to and including Midnight (Standard Time) of Monday immediately following date stamped on back, except as otherwise provided in tariff regulations." Most travelers sought out the inexpensive rail transportation, and a railroad boom ensued. Such weekend excursion tickets encouraged many to visit Spotswood in pursuit of its attractive recreational sites.

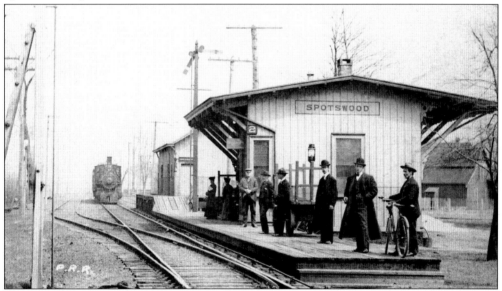

This view shows a train about to pull into the station, where eager passengers wait to board the train. The Camden and Amboy Railroad line has run through Spotswood since its inception in the early 1800s. The passenger station shown here was located on the present property of Jersey Pride on Snowhill Street. The siding to the left ran from Snowhill Street to East Main Street. It was often used to hold the coal cars and allow the passenger trains to pass through.

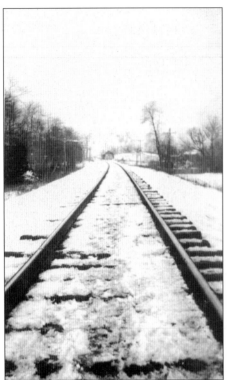

The railroad tracks pictured here spanned across central New Jersey from Amboy to Camden. In this scene looking east toward Snowhill Street, the station is visible in the distance. The Asbury Fuel Oil Company was located on the right. The railroad and overland roads brought a measure of prosperity to Spotswood. They provided a way to transport the agricultural output of the interior and encouraged the growth of industry.

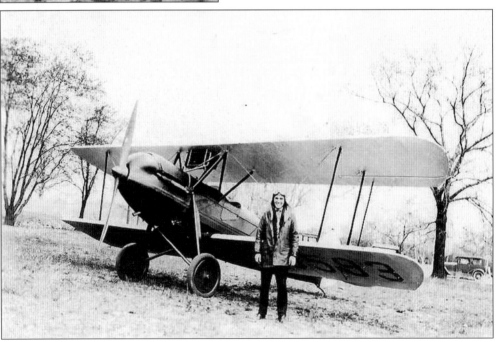

Local pilot John Uhl poses here with his biplane in the 1920s. Legend has it that this plane was built in a barn on Old Stage Road in East Brunswick. The wingspan, however, supposedly exceeded the width of the barn door, and an entire wall of the barn had to be torn down to move the plane into flying position.

John Uhl often used an empty field along Summerhill Road as a landing strip for his biplane.

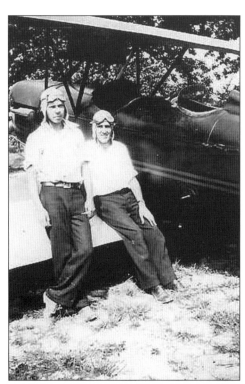

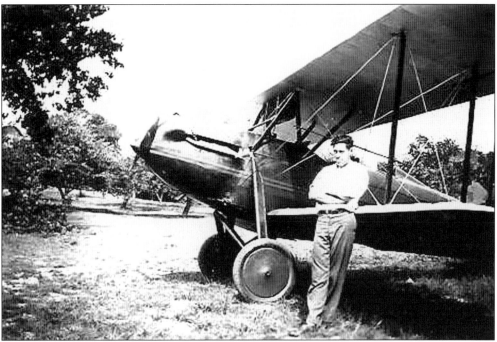

John Uhl, uncle of Harvey, Howard, and Tressa Uhl, lost his life at the age of 21 on September 5, 1931, along with his passenger, Herbert VanDyke, when their aircraft crashed. It is believed that the cause of the crash was the loosening of a wing on the aircraft. It came down on Old Stage Road, near where the Christ Memorial Lutheran Church stands today.

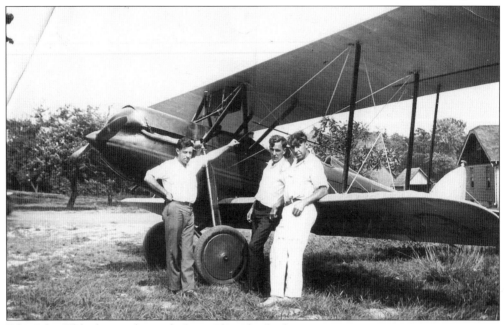

Pilot John Uhl often took people for a ride in his biplane.

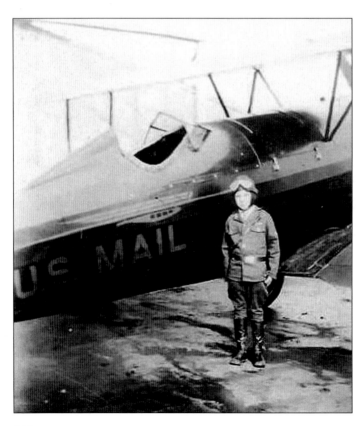

This photograph shows how airmail was delivered to some post offices in rural areas of New Jersey.

Ten
PARADES, STREETS, ROADS, AND BRIDGES

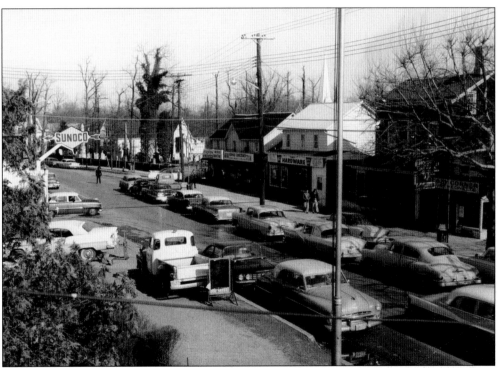

Main Street and DeVoe Avenue are shown as they appeared in 1957. Police captain George Ahrend took this picture from police headquarters when it was located on the second floor of the community house. With no traffic light to direct traffic at the intersection of Main Street and DeVoe Avenue, a police officer had to be assigned to direct traffic. Parking was allowed along both sides on Main Street to accommodate the Cozy Corner, Gorski's Hardware, Vern and Auds Confectionary, the A & P, DeStefano Agency, and the Main Street Barber Shop.

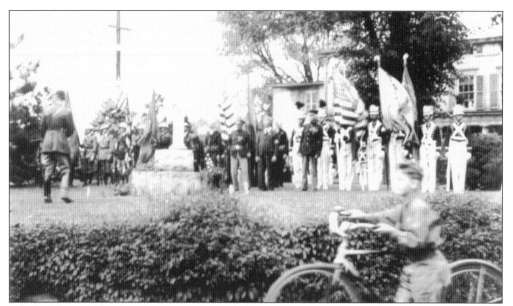

This World War I–era ceremony was photographed at Triangle Park, located at the intersection of Main Street, Snowhill Street, and Manalapan Road. The Firemen's Monument is not visible in this view; it was erected after World War II. The borough's veterans groups assemble here every Memorial Day to honor fallen comrades who have given their lives in service.

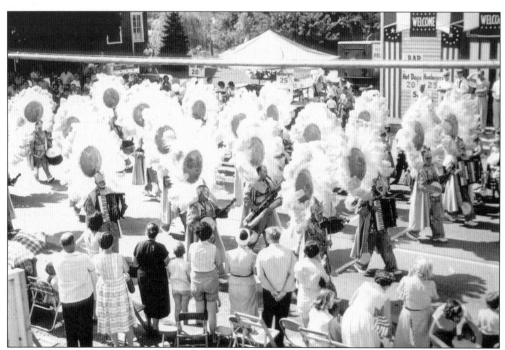

This 1958 photograph of a Memorial Day parade shows the famous Mummers from Philadelphia. The Polish American Club provided hamburgers for 25¢ and hot dogs for 20¢ to the many parade-goers. The parade assembled at the American Legion on DeVoe Avenue. The marchers would continue down Main Street, and the parade would terminate at P.J. Schweitzer's on Main Street.

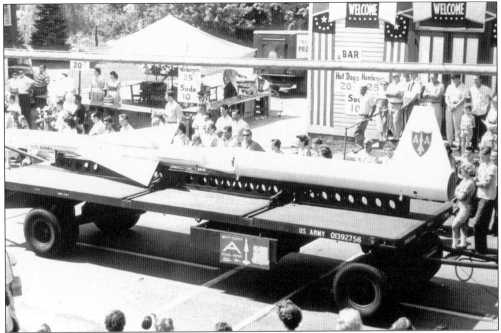

In this photograph of the 1958 Memorial Day parade, the U.S. Army Air Corps from Picatinny Arsenal displays a Nike missile. These missiles have not been seen in parades for many years. During the Eisenhower era, the nation's military defense capabilities were a source of pride in our country. As the military honor guards passed in review, they would discharge their weapons in a salute. Borough youths would scramble onto the parade route to retrieve the empty shell casings.

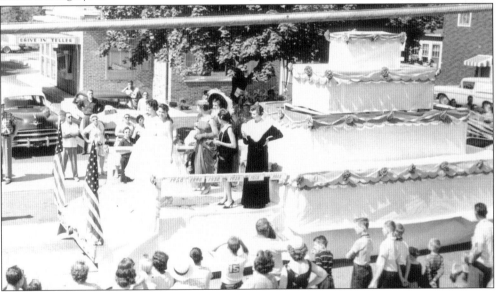

In this 1958 view, a float proudly carries some of Spotswood's beautiful women, who are wearing fashions from the six decades that the borough had been incorporated (1908–1958). Other borough organizations whose members marched in this parade included the American Legion, Veterans of Foreign Wars, Boy Scouts, Girl Scouts, baseball teams, the fire department, and the Spotswood First Aid Squad. Borough officials also marched.

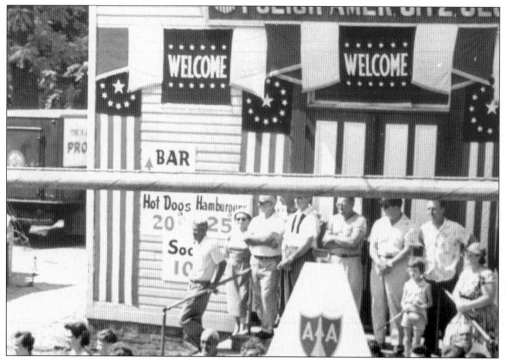

Notice the prices displayed for refreshments in this 1958 photograph of the Memorial Day parade: 20¢ for a hotdog and 10¢ for a soda.

The parade celebrating the 50th anniversary of the borough was held on August 30, 1958. It was also the occasion of the 60th anniversary of the Spotswood Fire Department. Pictured marching down Main Street are Commissioner Russell F. Kane (center) and William Fitzgerald (right), captain of the Spotswood First Aid Squad. Fitzgerald, a longtime borough resident, was a custodian at the Appleby School. Later, after the Spotswood High School was constructed, Fitzgerald became the superintendent of buildings and grounds for the board of education.

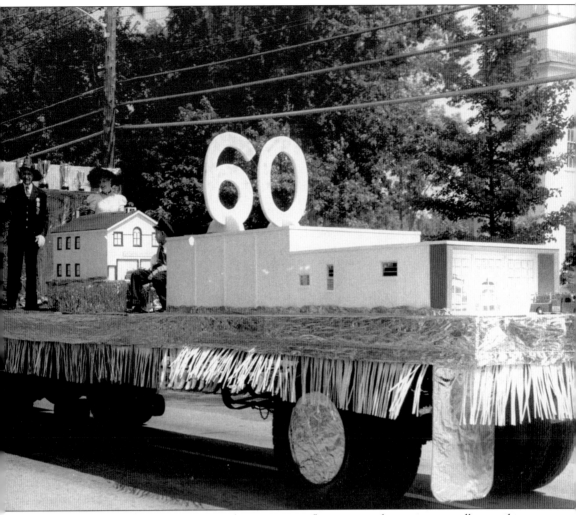

The Spotswood Fire Department's 60th-anniversary float is seen here as it proudly parades down Main Street. Riding on the float are John P. Applegate, the oldest living fireman in the community at that time, and Peg Larkin, a charter member of the Ladies Auxiliary. The fire department buildings seen here were constructed by Edward Wilson.

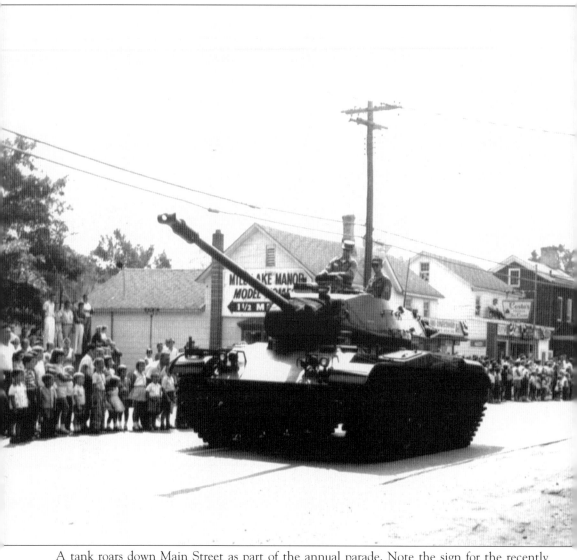

A tank roars down Main Street as part of the annual parade. Note the sign for the recently opened Mill Lake Manor housing development, located on DeVoe Avenue in Monroe Township. This development brought increased traffic to the area, and the borough is still trying to deal with the problem today.

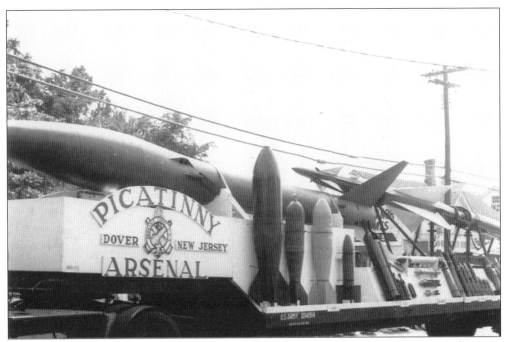

A float representing Picatinny Arsenal proudly displays a mobile missile battery in the 1958 parade. At the height of the cold war, average Americans were very concerned with the nation's ability to hold off the Soviet menace.

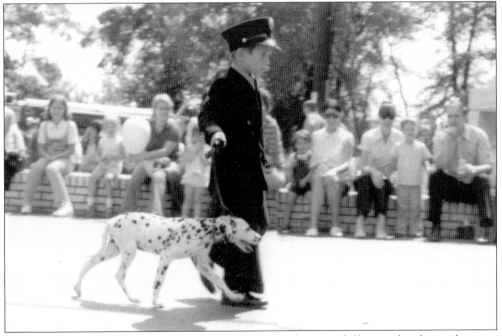

This photograph, taken on Manalapan Road facing the Snowhill triangle, shows the next generation of firefighters at the Memorial Day parade in 1973. For several years in the 1970s, this parade began at the Veterans of Foreign Wars post on Daniel Road and terminated at the American Legion post on DeVoe Avenue.

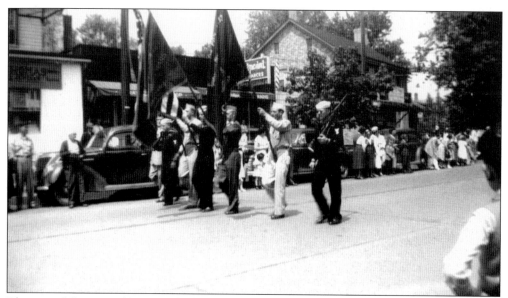

The annual Spotswood Memorial Day (originally known as Decoration Day) parade has always been led by an honor guard consisting of a local representative of each national military service branch. Note Hodapp and Troch's Hotpoint appliance store in the background. The tall building in the background is the Main Street Market, owned by Alvin and Gladys (Goldie) Zagnit, parents of Mayor Barry Zagnit.

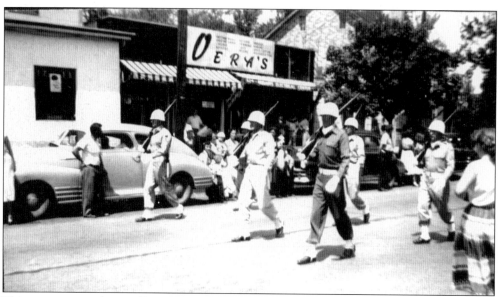

This picture was taken on Decoration Day in 1950.

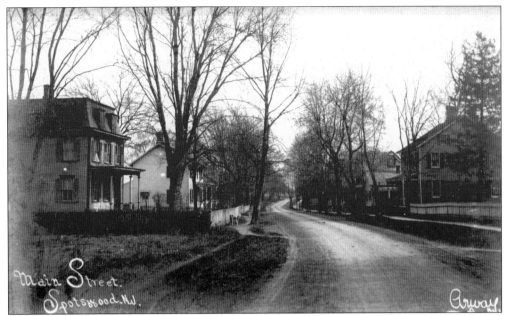

Main Street is seen in 1906 from a spot directly in front of what is now the post office property. The house in the left foreground was owned for many years by Mrs. Perrine. It was torn down in the early 1990s. The house on the right was owned by the Grace family for many years. The white house in the background on the left is now the office of Bonamici and Colletti, Certified Public Accountants. In 1908, Mayor Arthur Appleby noted that paving the streets and installing sidewalks was one of his highest priorities upon taking office.

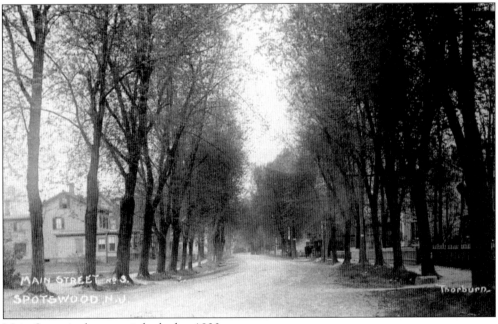

Main Street is shown as it looked c. 1920.

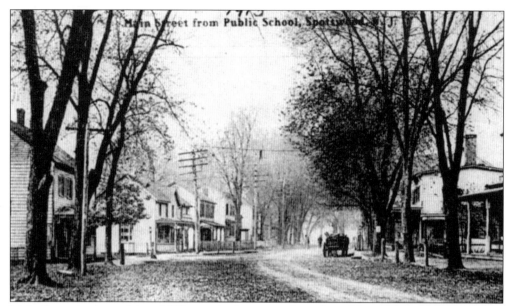

Main Street is pictured in a 1912 view looking west from the public school. At the time, the borough was governed by a mayor and council. Town government members included William J. Bissett, Augustine Cornell, Augustus DeVoe, Hamilton Hazelhurst, Joseph Hodapp Jr., and T. Francis Perrine. Phineas Mundy Bowne was justice of the peace of the borough at this time and held the position for 40 years. He also served as the second mayor of Spotswood and the borough clerk, until he resigned at the age of 93.

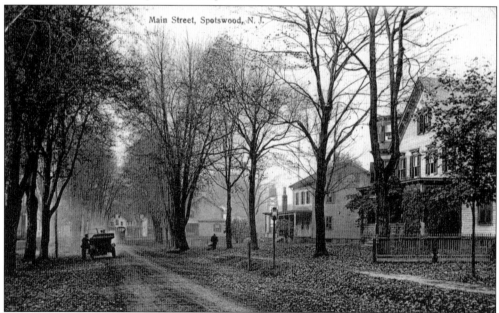

Seen here is Main Street in the early 1900s. The house on the right was owned by Arthur Appleby. Note the gas lamp in the front, along with the hitching post. The horseless carriage had come to town to travel a much narrower version of Main Street and coexisted peacefully with the horse-drawn carriage (in the background). The water tower in the background was part of the Vliet's Hotel complex.

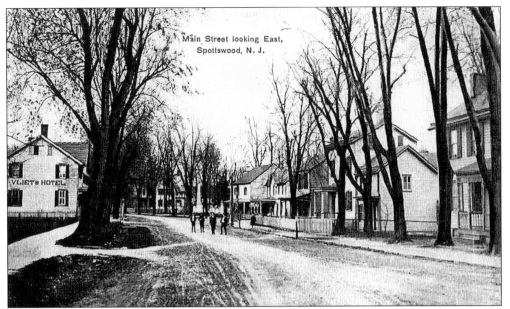

Looking east from the fork in the road, this c. 1900 view shows downtown Main Street. The monuments on the right are in St. Peter's Episcopal Church cemetery. (The red brick wall and gate around the cemetery were not built until the 1920s.) The building to the right of the monuments was the original town post office. The first building from the right, the last building with a Main Street address when one travels west, still exists. It is now the office of Dr. Alan Mazurek.

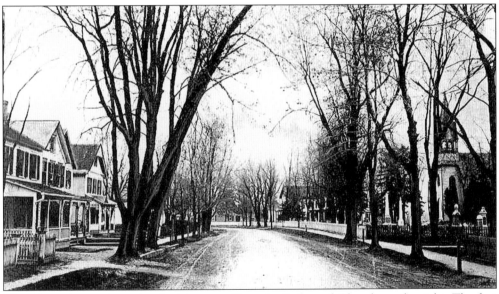

Main Street is seen in a view looking east. Note the Reformed Church on the right. The first house on the left still stands and has been owned by the Jolly family since the 1800s. The second house on the left was occupied by Applegate and Mrs. Kale during the mid-20th century. The third house on the left has been razed. At one time, it was the location of Dr. Bergen's office, and at another time, it served as the headquarters of the local confectioners union.

Adirondack Avenue is seen in this mid-1950s photograph. In the post–World War II era, Spotswood began to grow, as did other suburban communities. New houses were built, largely located in Clover Estates, between Burlington Avenue and Old Stage Road, and between Ellenel Boulevard and Brunswick Avenue. The name "Clover Estates" was taken from Clover Hill Farms, which sat on this land at the north end of town.

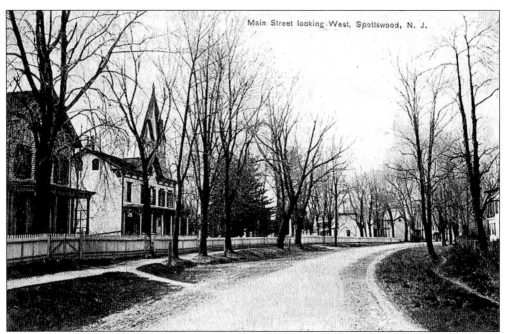

Taken in 1917, this view of Main Street looks west. In that year, Mayor J. Randolph Appleby Sr. named his son J. Randolph Appleby Jr. as borough attorney, a position later held by his son J. Randolph "Bud" Appleby III. Bud Appleby practiced law on East Main Street in a small white facility now occupied by Maddox Trucking.

This photograph shows the intersection of Main Street and DeVoe Avenue in the 1940s. It was taken from atop the water tower on the old DeVoe Mills property, which is now the home of the American Legion. Clover Hill Farms is visible at the top of the photograph.

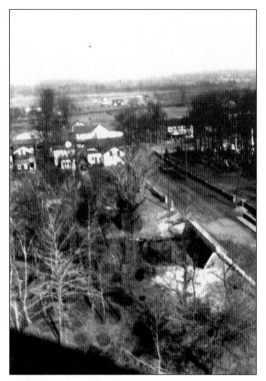

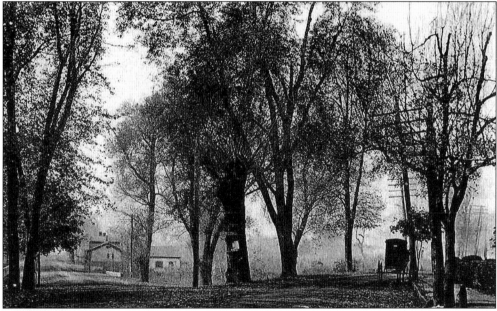

The Bordentown Turnpike was a primary route from the Amboys to Trenton. This view shows the West End Hotel on the right. The well-known triangle has not yet been constructed. Benny's Tavern was erected later, behind the trees in the foreground in this view. At about this time, the borough enacted an ordinance that stipulated that vehicles such as bicycles, tricycles, and motorized vehicles should not be propelled at a greater rate of speed than eight miles per hour. The penalty for a violation was a $10 fine or imprisonment in the county jail for 10 days.

The fork in the road, as it was known then, became the site of the borough's monument. In this view, the dirt road is seen before it was paved. Bennie's Tavern is visible in the foreground. While all borough hotels had bars to serve drinks, Bennie's was the first freestanding establishment in town to serve food and liquor. The Feldbaum brothers expanded their tavern to include a fish market on Snowhill Street. This business was later moved next door to a small brick building, which later became Carmen's Barber Shop.

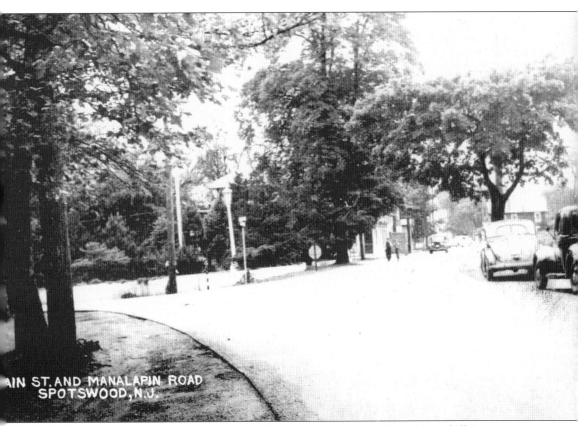

AIN ST. AND MANALAPIN ROAD
SPOTSWOOD, N.J.

In the 1930s, Main Street, Manalapan Road (Bordentown Turnpike), and Snowhill Street were improved. As part of a Work Projects Administration initiative, the old dirt road was paved with concrete. Note Bennie's Tavern, shown here to the right of the now-landscaped triangle. In 1939, Spotswood's type of government was changed to the commission form, following a referendum in September of that year.

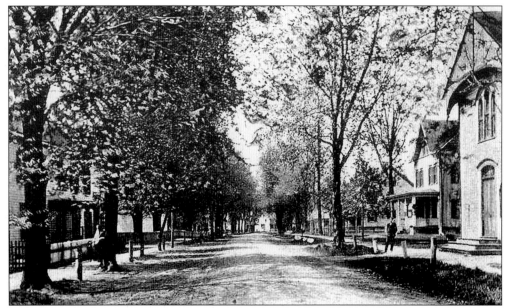

Looking west, this 1900 view shows lower Main Street. The first building on the right is Whitney Hall. The house next to the hall still stands today. Note the hitching posts, used for horses, up and down both sides of the road. The second house shown here on the left was razed by the early 1920s. This site was the location of the Immaculate Conception Church rectory and later the Eckman Funeral Home.

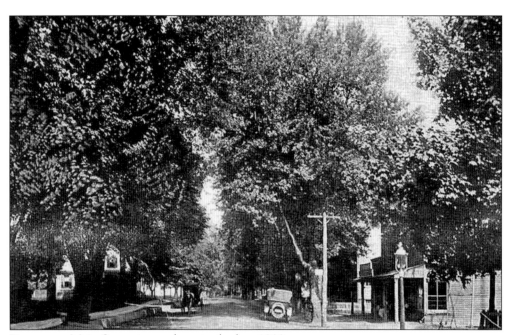

Downtown Main Street is seen here in the late 1900s.

This view of Main Street looks west.

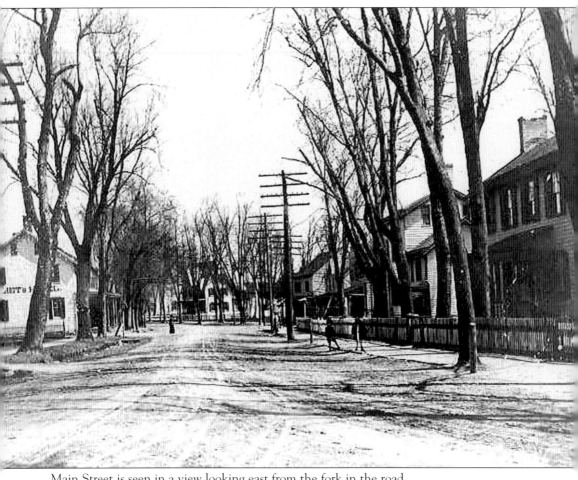

Main Street is seen in a view looking east from the fork in the road.

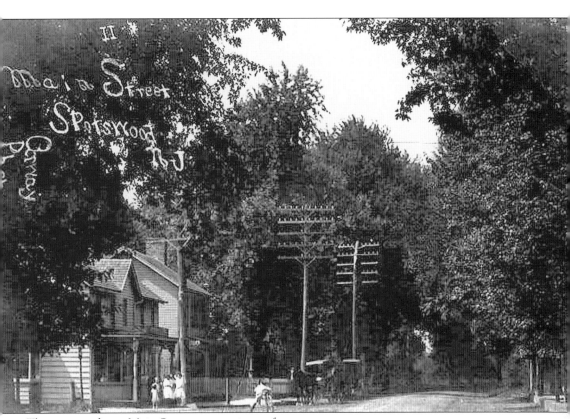

This picture shows Main Street on a summer afternoon.

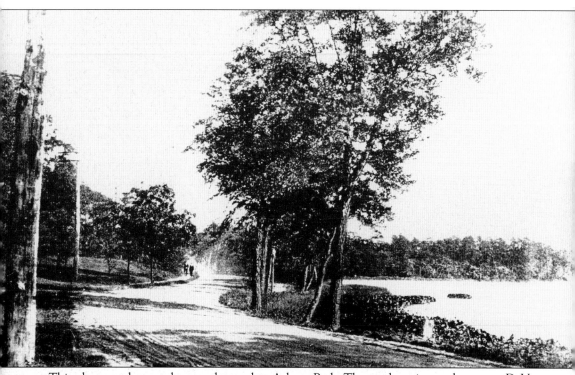

This photograph was taken on the road to Asbury Park. The roadway is now known as DeVoe Avenue. Before the days of the Garden State Parkway, roads such as DeVoe Avenue were the main thoroughfares for north Jersey residents trying to reach the shore resorts in Monmouth and Ocean County. Notice the absence of the T dock, which had not yet been constructed.

This is what DeVoe Avenue looked like in the late 1950s and early 1960s. A car is traveling south, passing the T dock on the right. The dock was built by the Patron family and used to launch recreational craft. Due to dredging of the lake over the years, the water's edge is now significantly farther from DeVoe Avenue. The Spotswood recreation commission still holds a fishing derby for borough youths every June near the dock.

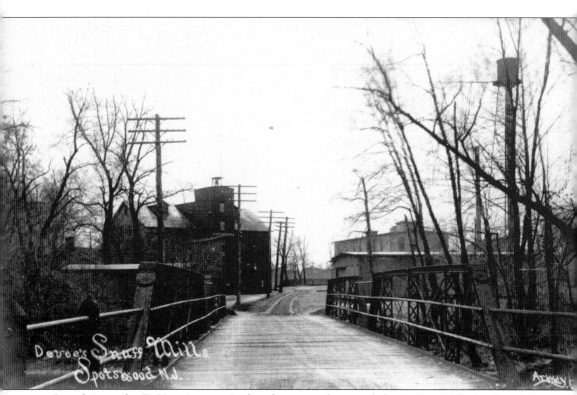

Seen here is the DeVoe Avenue Bridge, facing south toward the DeVoe Mills. In the 1900s, this area was known as Bridge Street. The bridge shown here was made of structural steel with wooden planks in order to handle the new loads associated with the onset of automobile travel.

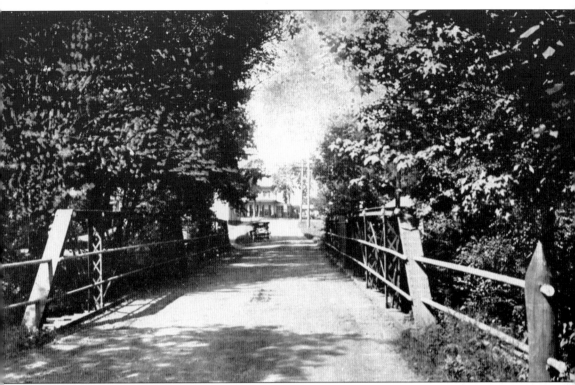

Bridge Street (DeVoe Avenue) is seen in this *c.* 1920 view looking north toward Main Street. The building in the background is Vliet's Hotel. Today, Vliet Street has been rerouted to meet DeVoe Avenue. G & S Auto and Pulaski Savings stand on either side of Vliet Street where it intersects Main Street. The lush foliage shown here recalls that the borough was originally carved out of a thick forest.

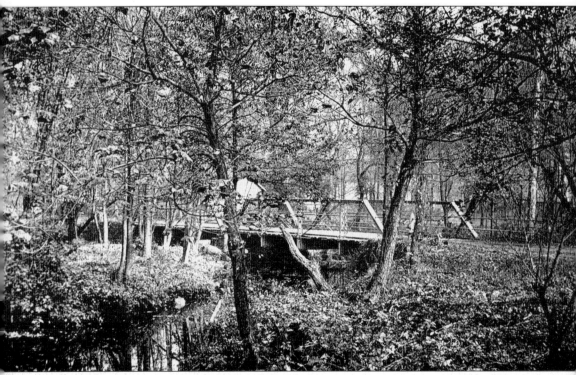

This is an early view of Bridge Street. The bridge that spans the Manalapan Brook is now known as the DeVoe Avenue Bridge. Before the borough installed storm sewers in the 1960s, borough youths enjoyed many a day discovering arrowheads and other Indian artifacts along the riverbanks. The river was much more accessible from Main Street than it is today. One could walk down Eisenhower Avenue or through many pathways to the river's edge and continue on down the river on well-trodden paths.

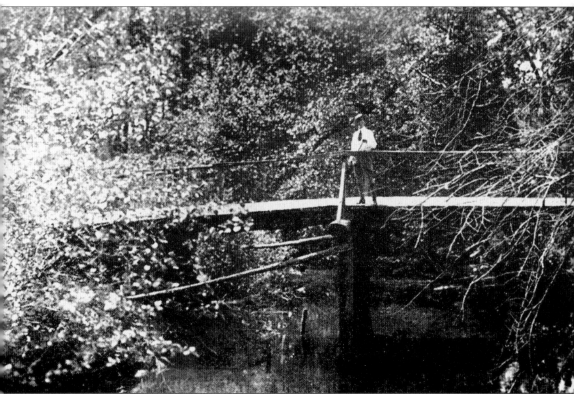

The footbridge, as it was known, was a favorite Sunday afternoon walking destination. There was a pungent odor of pine in the woods south of this bridge (near present-day Red Bank Road). These woods were home to patches of huckleberries, sand plums, and chestnuts. During the winter season, many game animals were hunted in this area. The authors remember sledding down the sizable embankment on the side of Red Bank Road, barely avoiding ending up in the cold Manalapan Brook at the bottom.

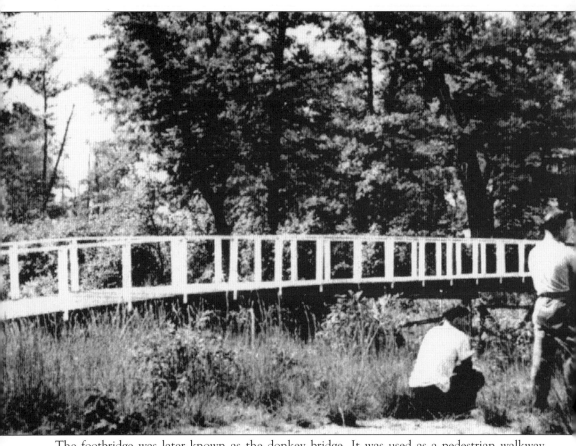

The footbridge was later known as the donkey bridge. It was used as a pedestrian walkway, linking George Street to Red Bank Road in the Brookwood section of Spotswood. The footbridge spanned the Manalapan Brook.